HIS FACE

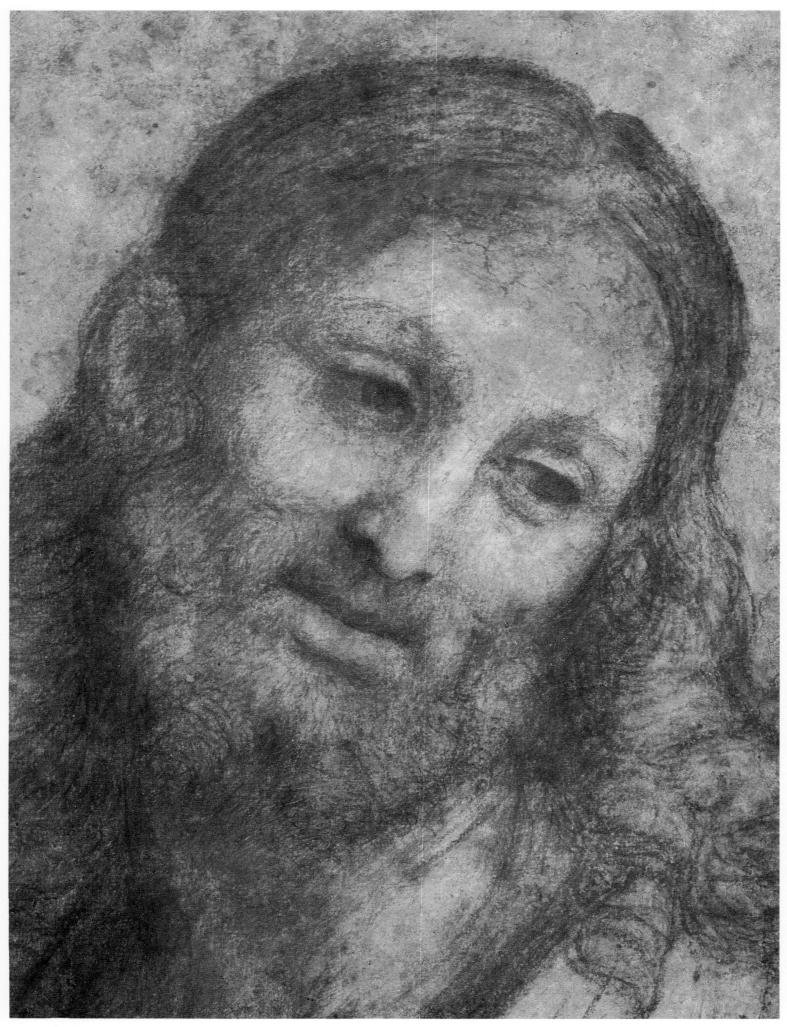

BERNARDINO LUINI, *BUST OF CHRIST*

HIS FACE

*Images of Christ
in Art*

Selections from
THE KING JAMES VERSION OF THE BIBLE

Edited by Marion Wheeler

CHAMELEON BOOKS, INC., NEW YORK

Published by Chameleon Books, Inc.
211 West 20th Street
New York, New York 10011

Designed by Arnold Skolnick
Typography by Larry Lorber, Ultracomp, New York
Printed and bound by O.G. Printing Productions, Ltd. Hong Kong

ISBN 0-915829-63-0
LC 88-071196

Contents

EDITOR'S PREFACE

*H*istorically, Jesus Christ's physical appearance remains a mystery. No one knows what he actually looked like. Nowhere in the gospels is he described, and no likeness of him of any kind in any form can be dated conclusively to the years of his life on earth. Yet his face is the most familiar and recognizable in Western iconography.

For centuries, rendering the essential qualities of Christ's divinity and humanity has dominated the creative energies and imaginations of the world's artists—from early unknown painters to the most celebrated masters. And, although each artist's conception is an individual representation of Christ, and each image may differ in terms of specific physical characteristics, the image portrayed is always immediately identifiable as that of Christ. For, although he is represented as a man among men, women, and children, the face of Christ, as rendered by the great painters, always reflects the unique dual nature of Christ as God and man. The result of this considerable artistic achievement is a legacy of visions of Jesus Christ that is at once aesthetically magnificent and spiritually enriching.

The idea for this book came after visiting the great art collections in America and Europe. So many of the faces of Christ remained vivid in our minds long after the memory of the paintings in which they appear had faded. Who could forget the gravely triumphant image of the resurrected Christ as painted by Piero della Francesca? Or Paolo Veronese's compassionate yet sorrowful Christ carrying the cross? Or Raphael's innocent yet preternaturally wise infant Jesus? The power of these images remains long after they are first seen and is renewed each time they are seen again, even in reproductions.

The choice of images in this book is necessarily arbitrary. It does not attempt to be anything other then a representative selection from the thousands of depictions of Jesus Christ in art. Those selected date from the twelfth century through the twentieth. Italian, Spanish, French, German, Dutch, and Flemish artists predominate simply because they produced so many of the most spiritually compelling and inspiring portraits of Christ.

Grateful acknowledgment is made to all those who helped produce this book; special thanks are owed to John Roberts and Joel Rosenman, Astrid Seeburg, Alan Kanterman, Joseph Lada, Roberta Halpern, Marilee Talman, Stephen Frankel, and Perry Brooks for their invaluable assistance.

M.W.

HIS YOUTH

Behold, a virgin shall be with child, and shall bring forth a son, and they shall call his name Emmanuel, which being interpreted is, God be with us. MATTHEW 1:23

GEORGES DE LA TOUR, *THE NATIVITY*

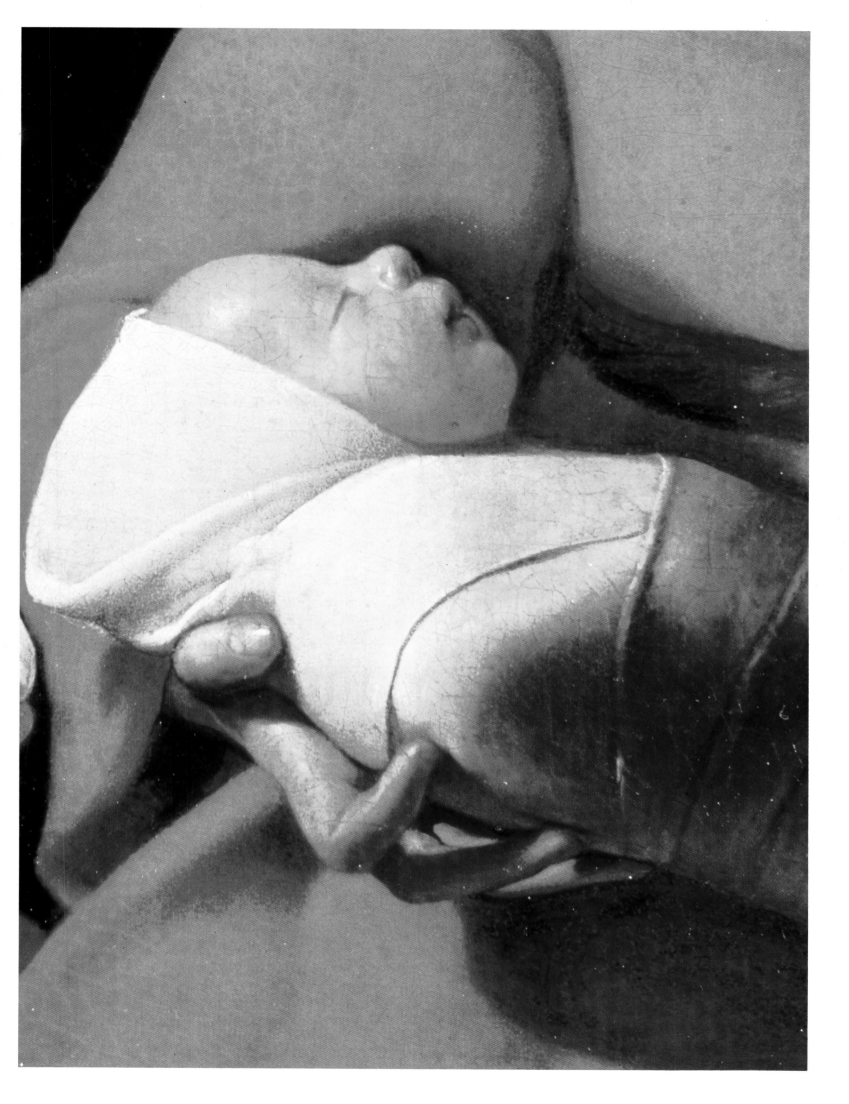

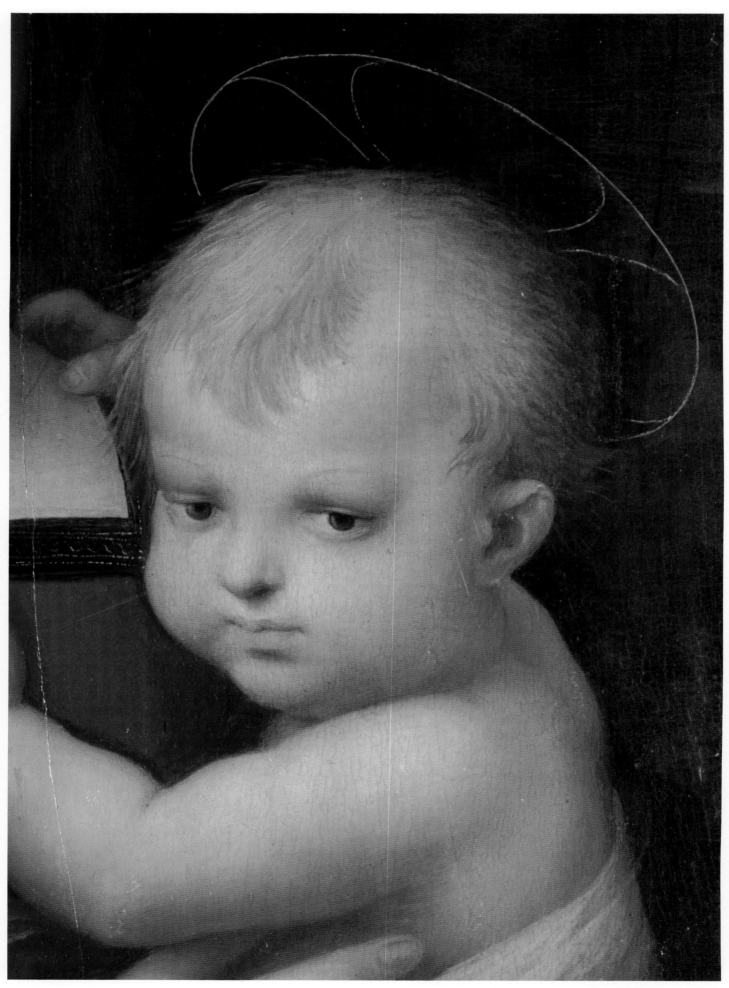

RAPHAEL, *MADONNA OF THE GRAND DUKE*

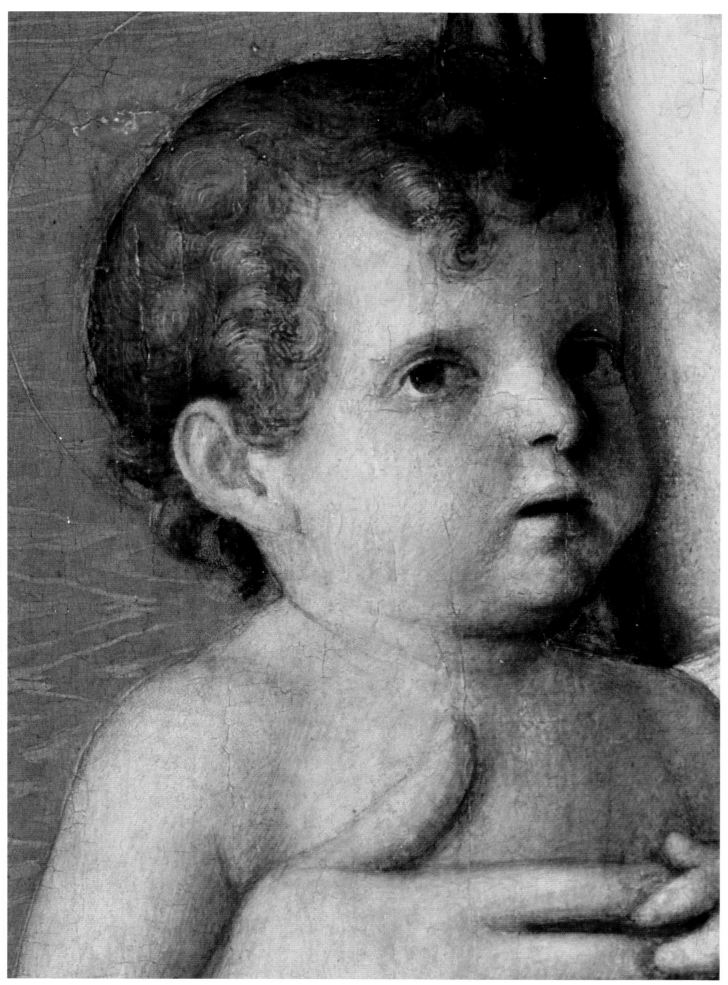

GIOVANNI BELLINI, *MADONNA DEGLI ALBERELLI*

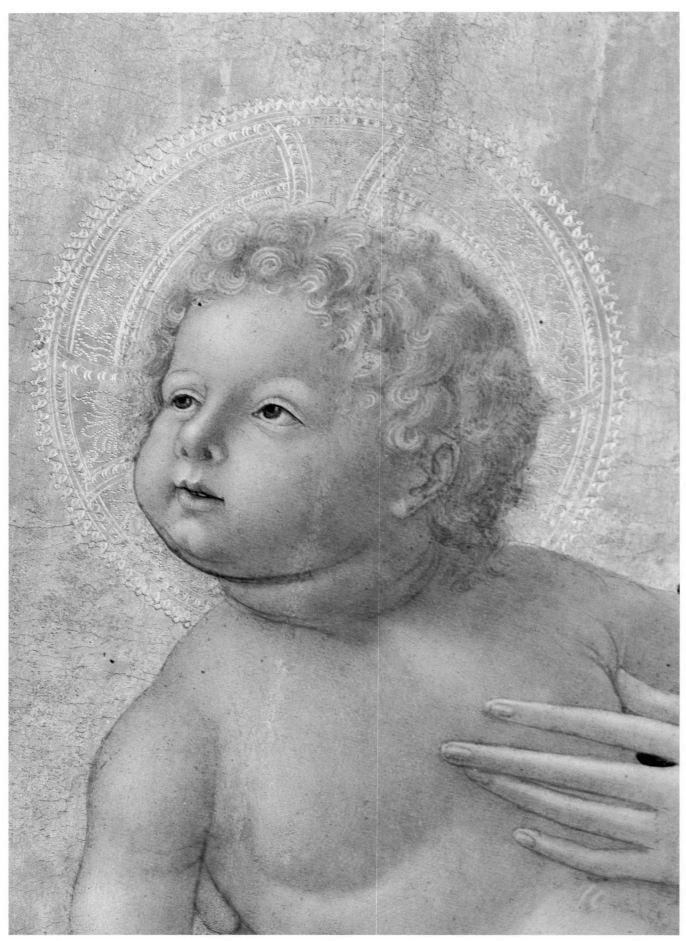

NEROCCIO, *MADONNA AND CHILD WITH ST. ANTHONY ABBOT AND ST. SIGISMUND*

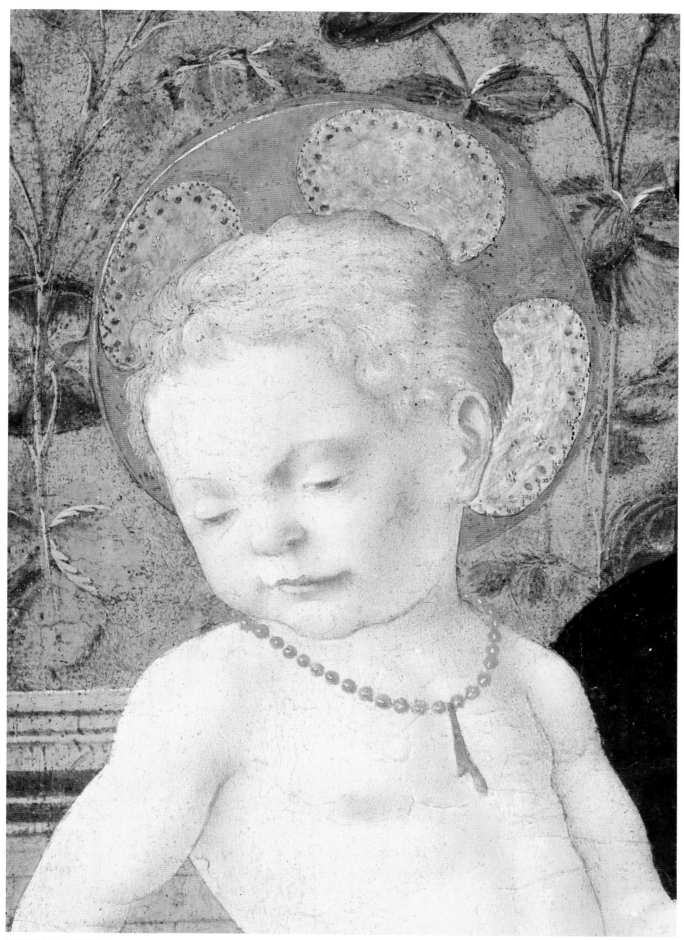

SCHOOL OF PIERO DELLA FRANCESCA, *VIRGIN AND CHILD WITH ANGELS*

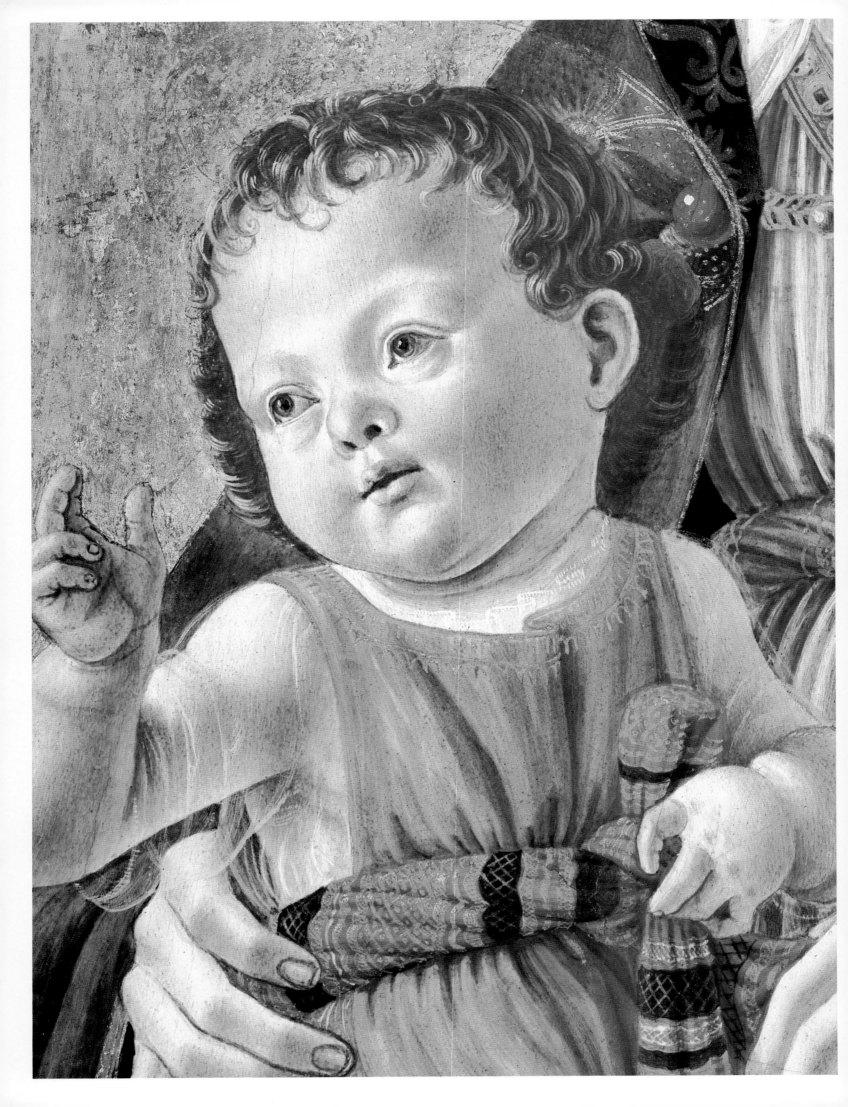

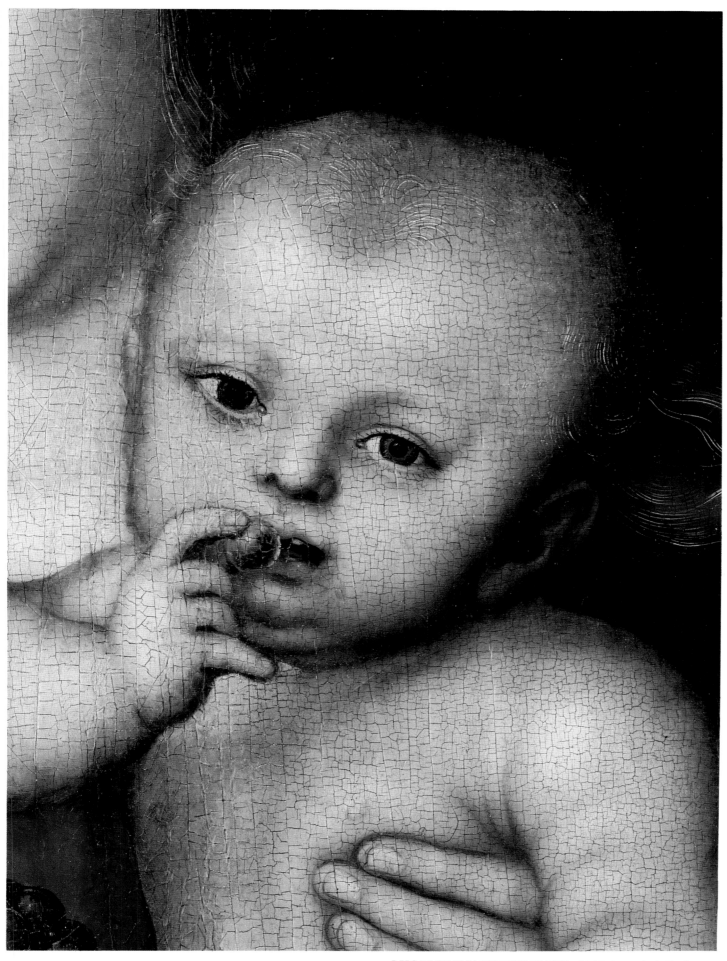

LUCAS CRANACH THE ELDER, *MADONNA AND CHILD*

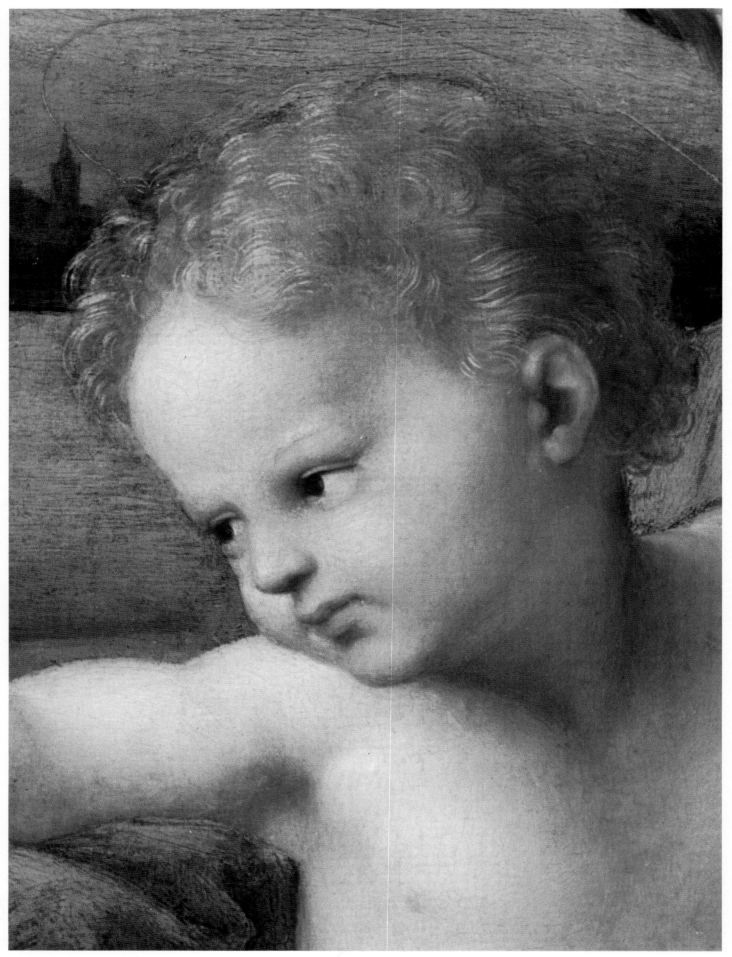

RAPHAEL, *THE ALBA MADONNA*

GIOVANNI BATTISTA TIEPOLO, *MADONNA OF THE GOLDFINCH*

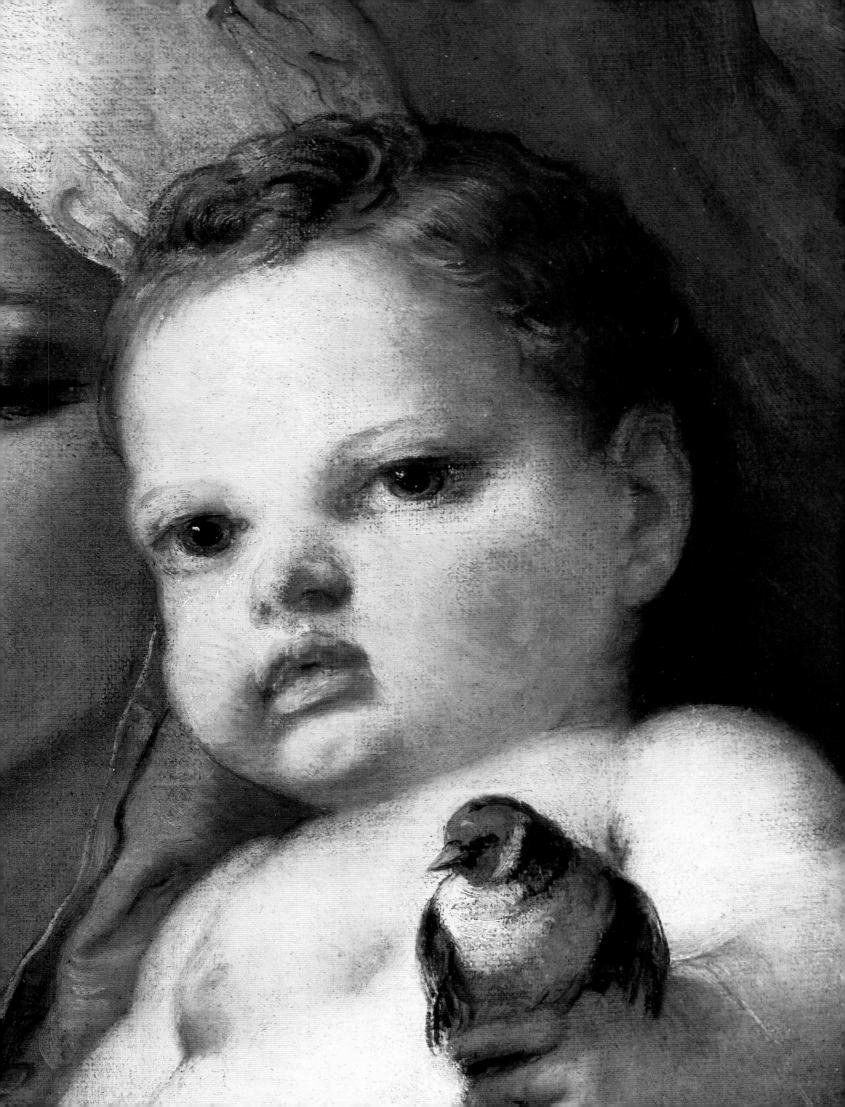

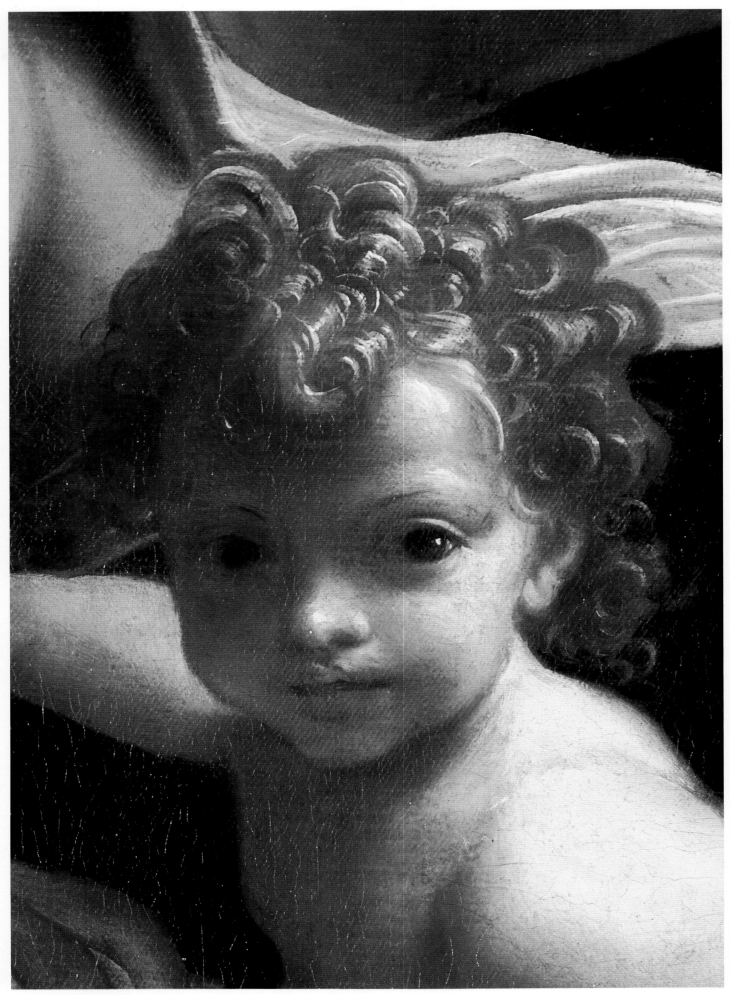

LUDOVICO CARRACCI, *THE DREAM OF ST. CATHERINE OF ALEXANDRIA*

MICHELANGELO CARAVAGGIO, *MADONNA DEI PALAFRENIERI*

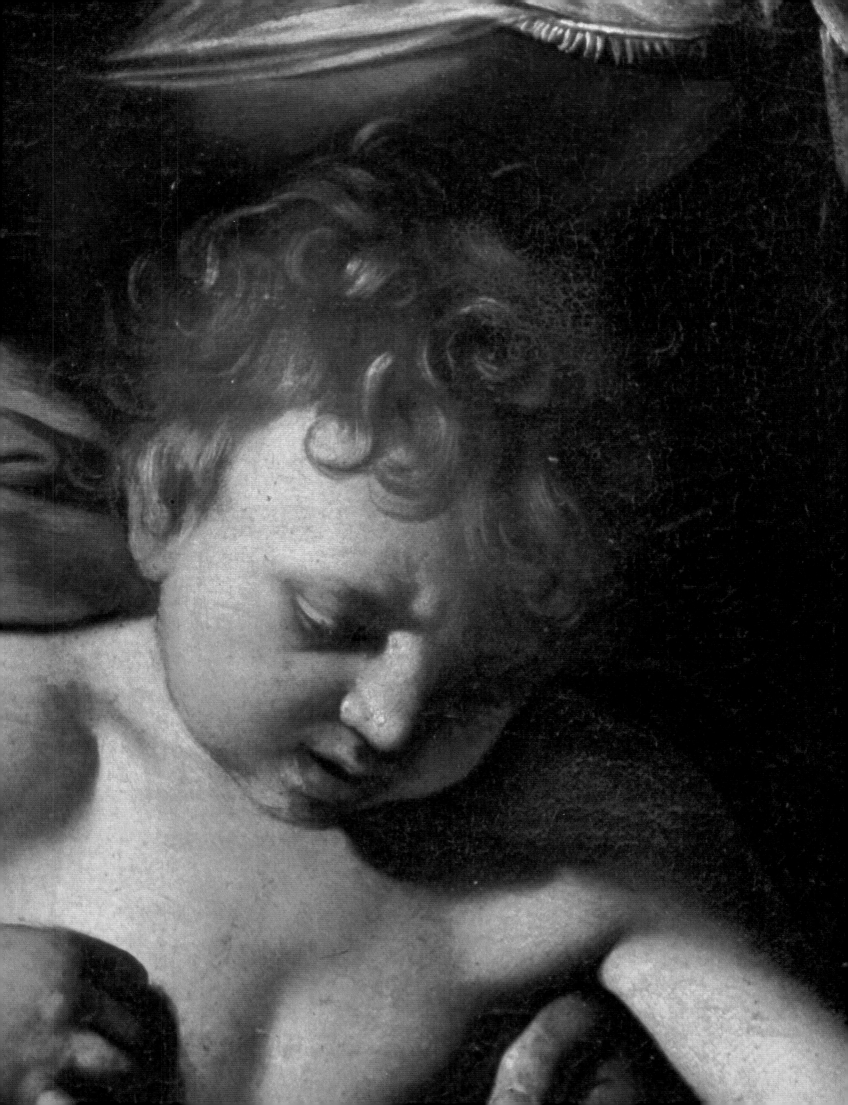

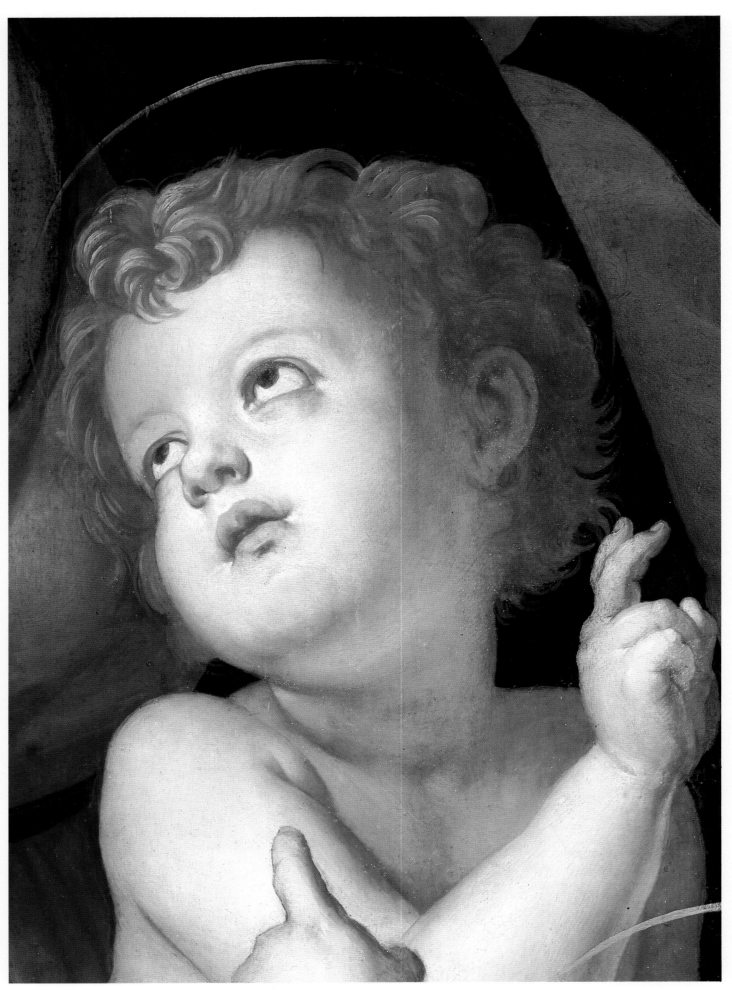

PONTORMO, *THE HOLY FAMILY*

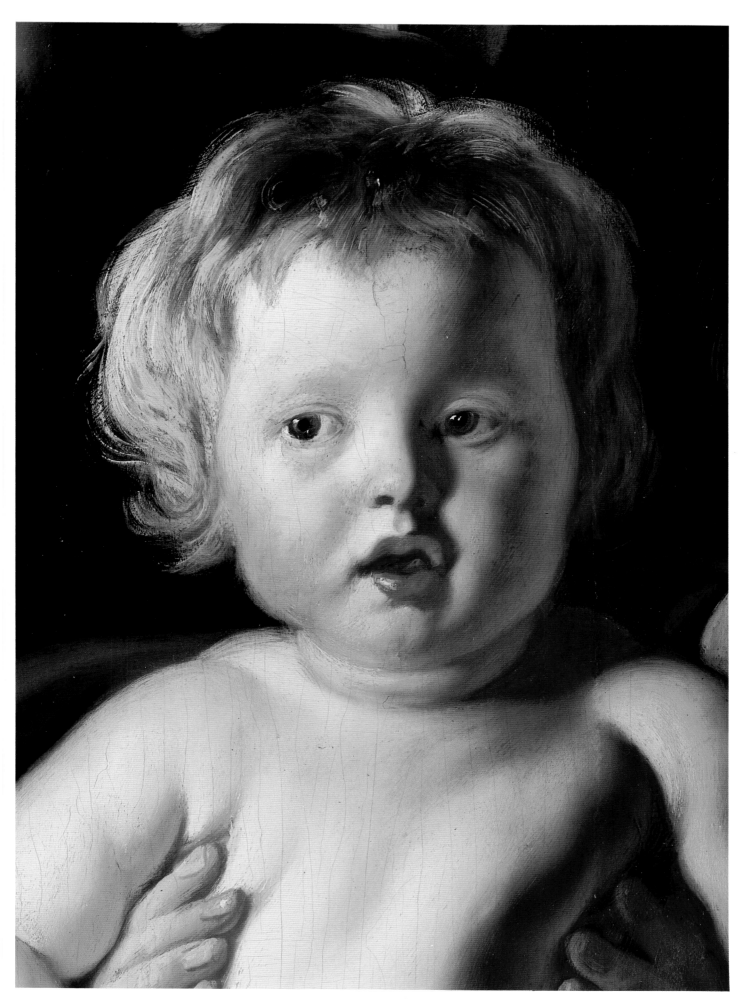

JACOB JORDAENS, *HOLY FAMILY*

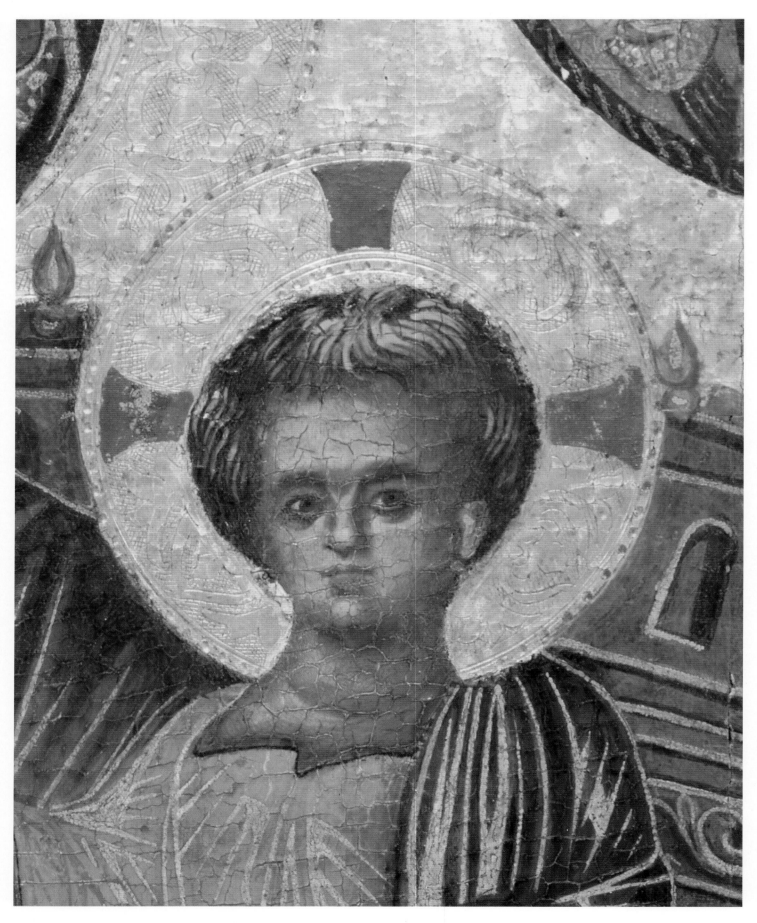

MARGARITONE, *MADONNA AND CHILD ENTHRONED*

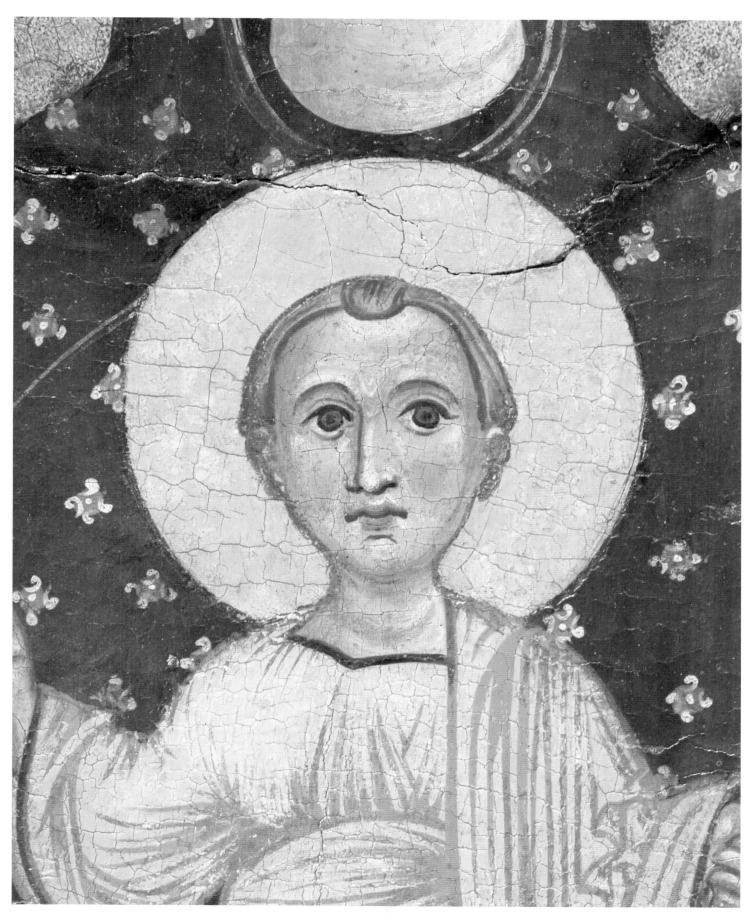

BYZANTINE, *MADONNA AND CHILD ON A CURVED THRONE*

And the child grew, and waxed strong in spirit, filled with wisdom: and the grace of God was upon him. LUKE 2:40

GEORGES DE LA TOUR, *ST. JOSEPH, THE CARPENTER*

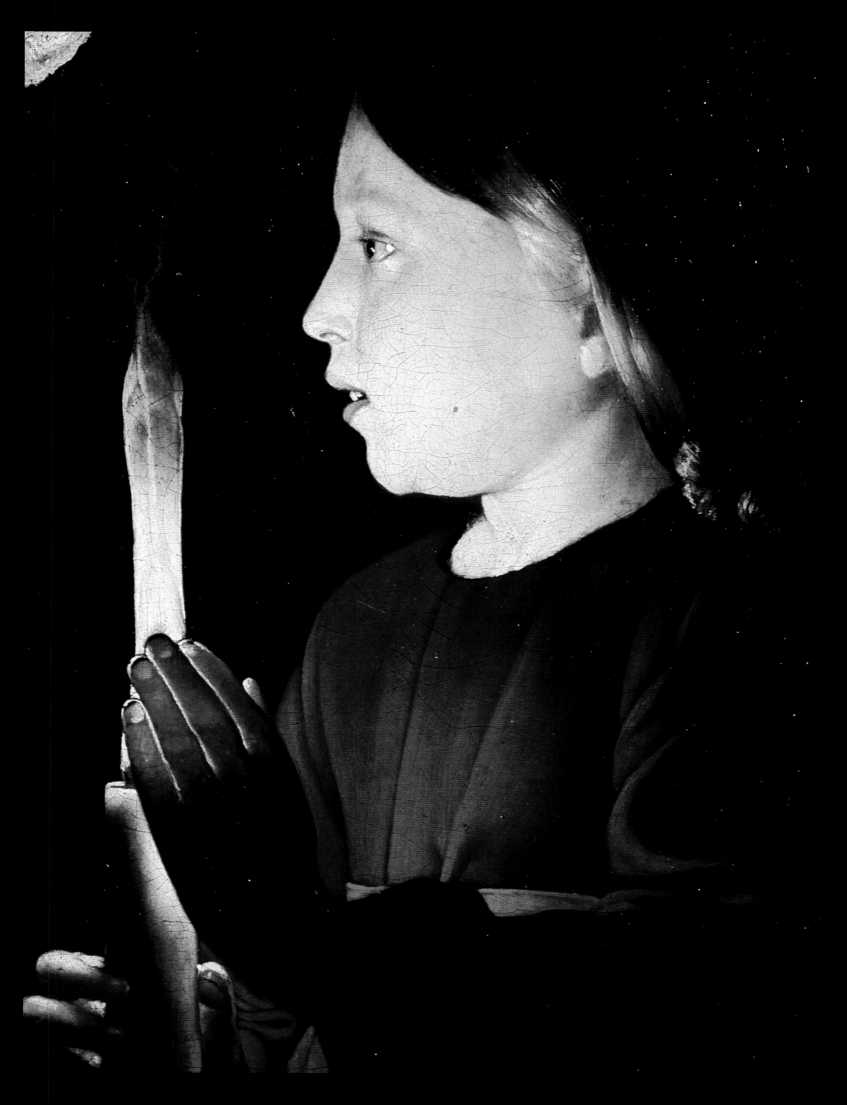

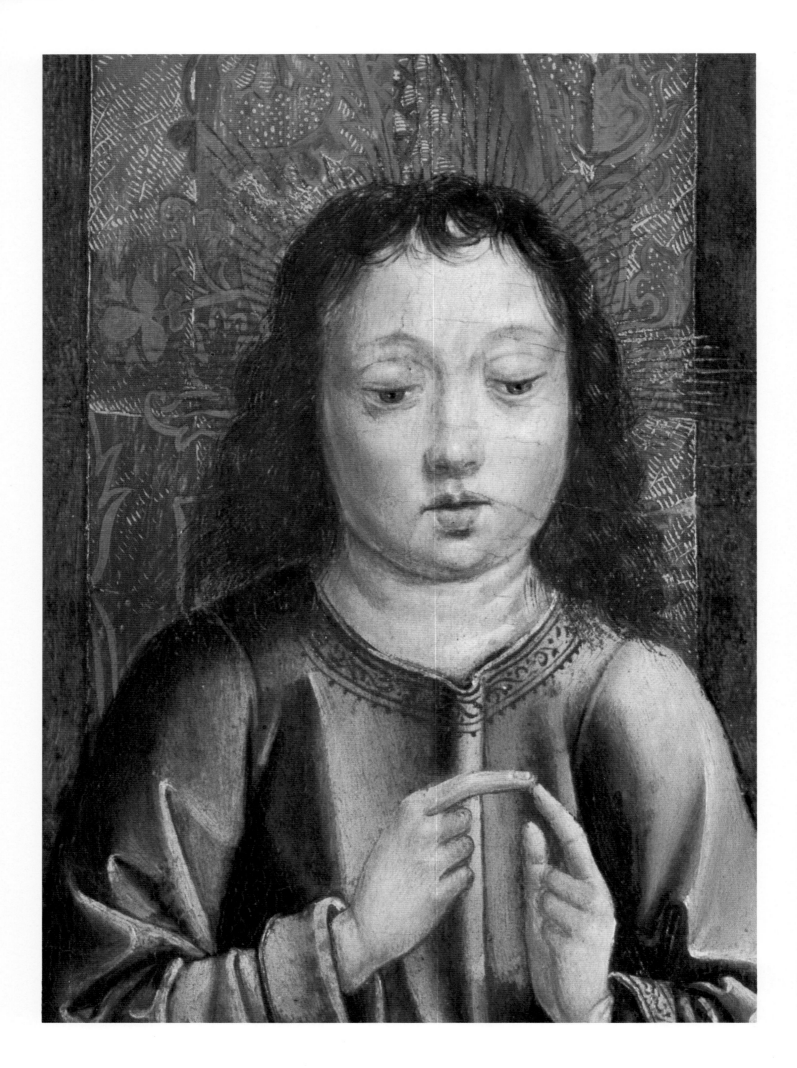

*A*nd when he was twelve years old, they went up to Jerusalem
after the custom of the feast. And when they had fulfilled the days,
as they returned, the child Jesus tarried behind in Jerusalem;
and Joseph and his mother knew not of it. LUKE 2:42–43

*A*nd it came to pass, that after three days they found him in
the temple, sitting in the midst of the doctors, both hearing them,
and asking them questions. And all that heard him were
astonished at his understanding and his answers. LUKE 2:46–47

MASTER OF THE CATHOLIC KINGS, *CHRIST AMONG THE DOCTORS*

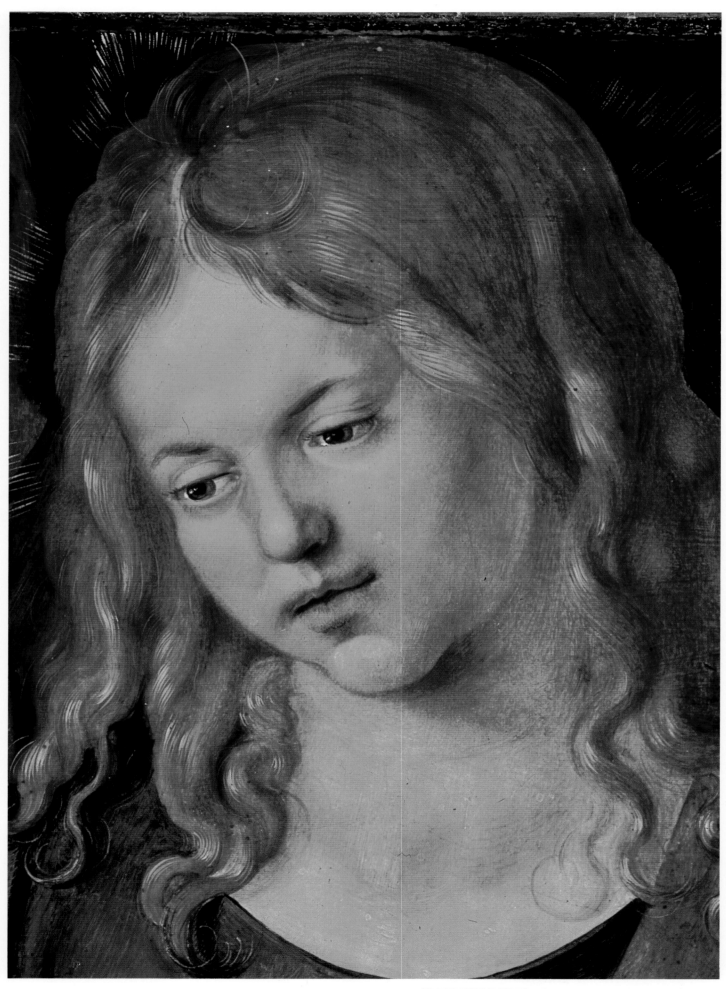

ALBRECHT DURER, *CHRIST AMONG THE DOCTORS*

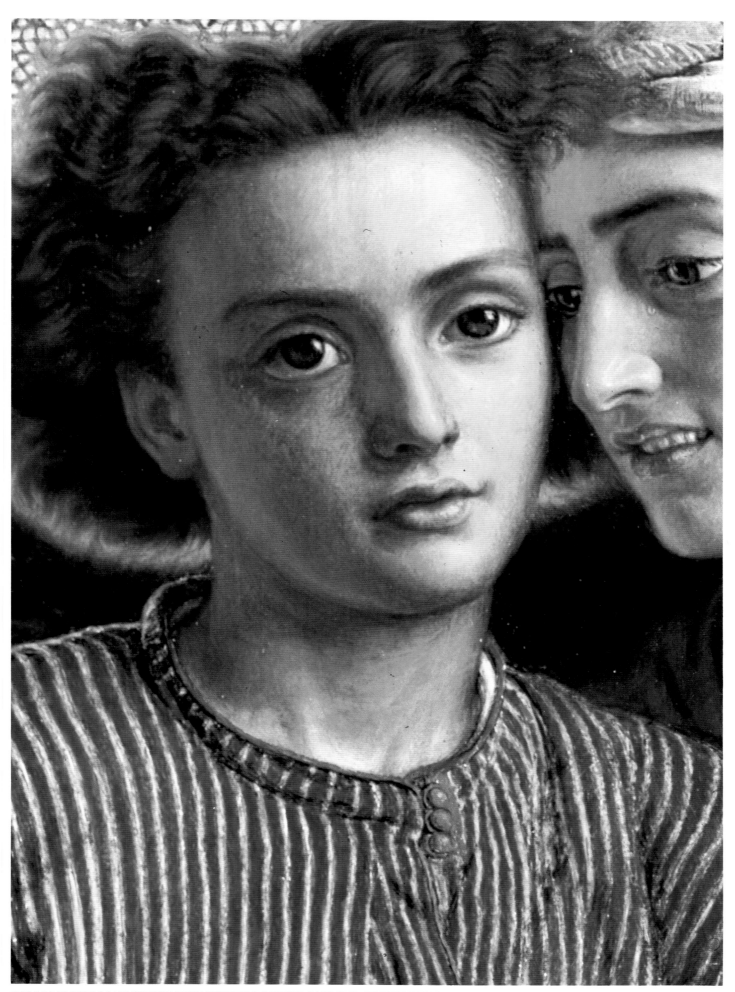

WILLIAM HOLMAN HUNT, *THE FINDING OF THE SAVIOUR IN THE TEMPLE*

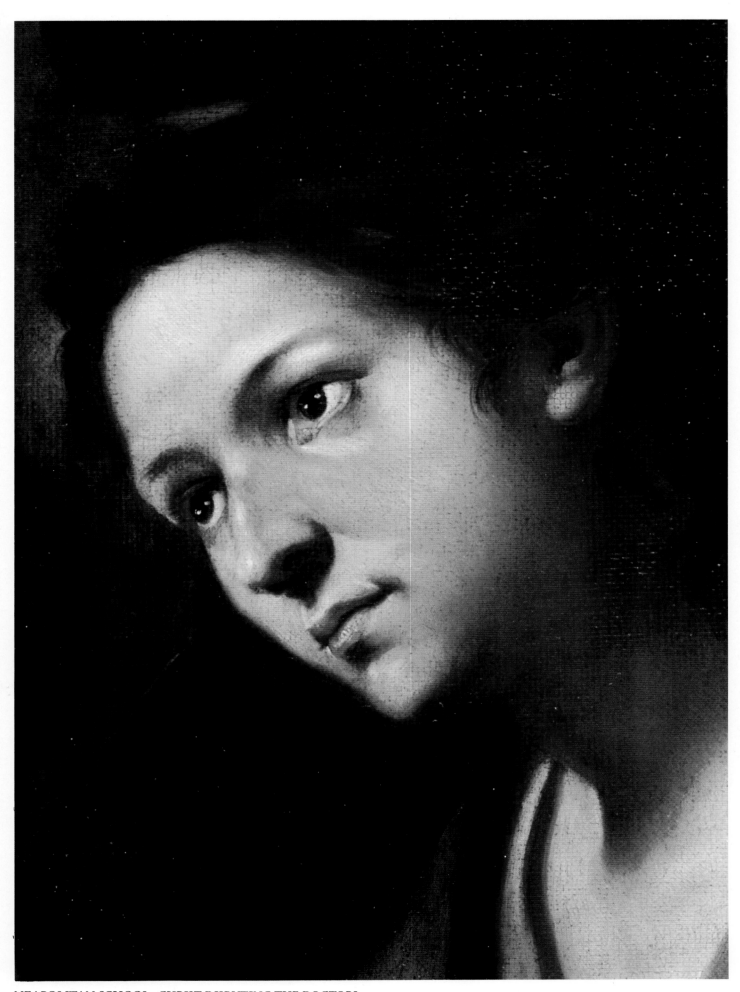

NEAPOLITAN SCHOOL, *CHRIST DISPUTING THE DOCTORS*

JEAN LECLERC, *CHRIST AMONG THE DOCTORS*

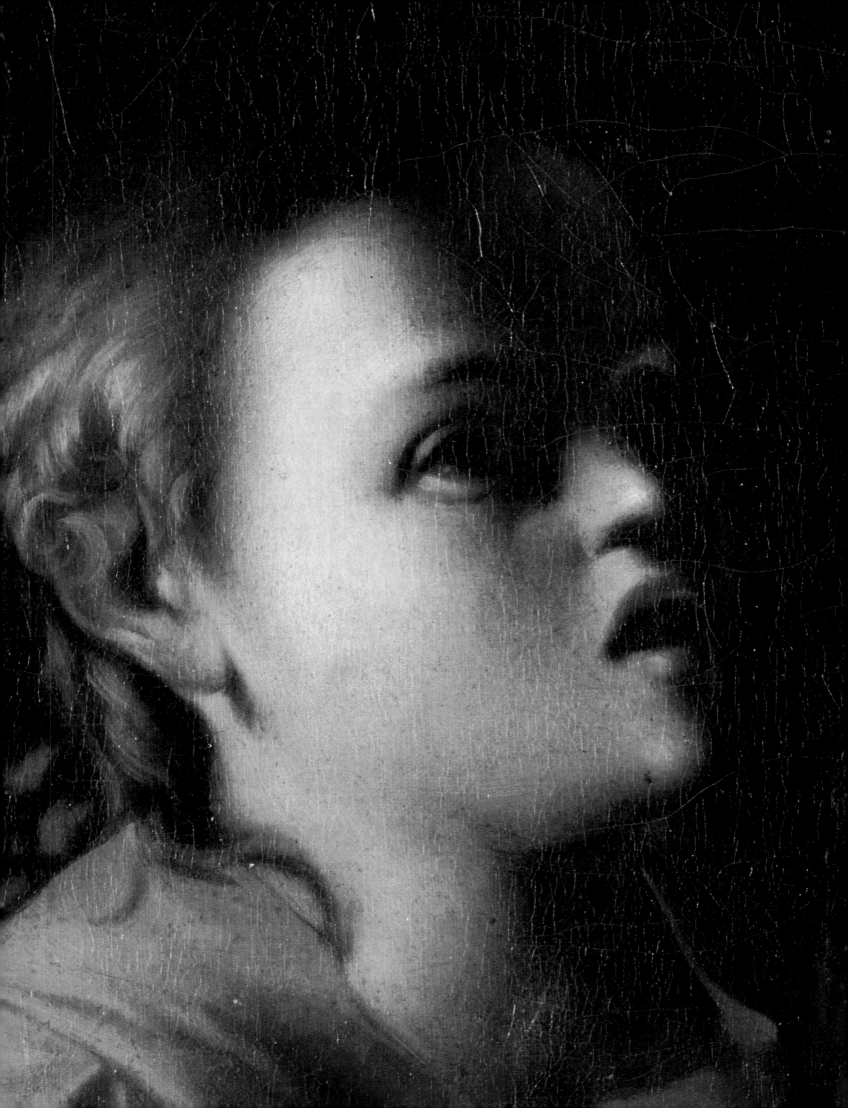

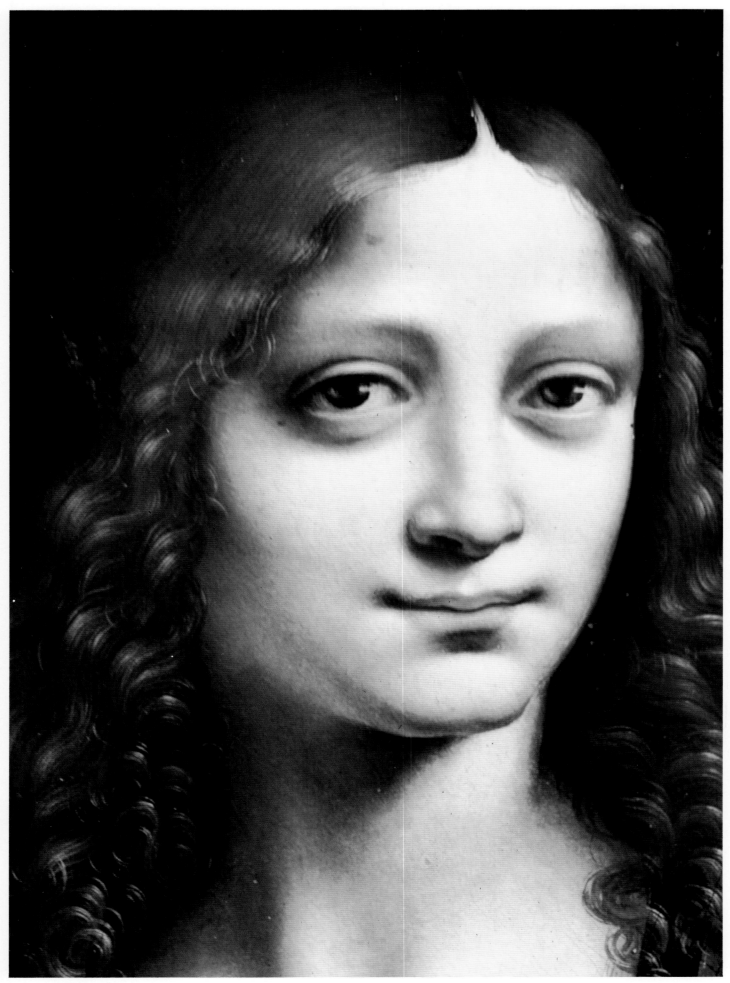

MARCO D'OGGIONO, *THE SAVIOR*

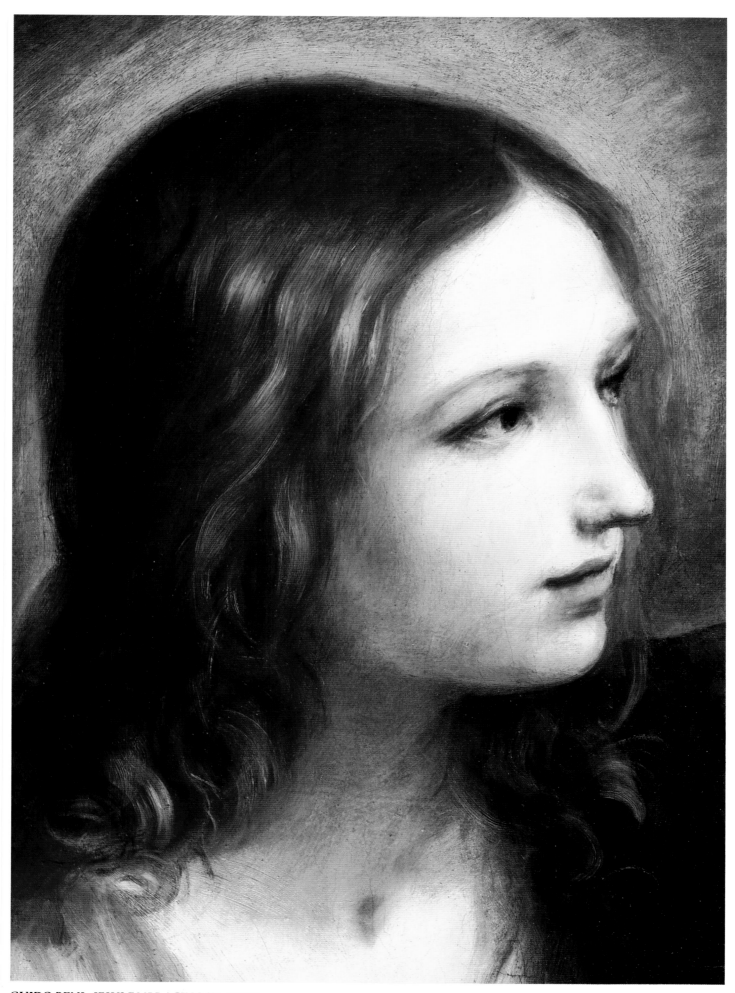

GUIDO RENI, *JESUS EMBRACING ST. JOHN*

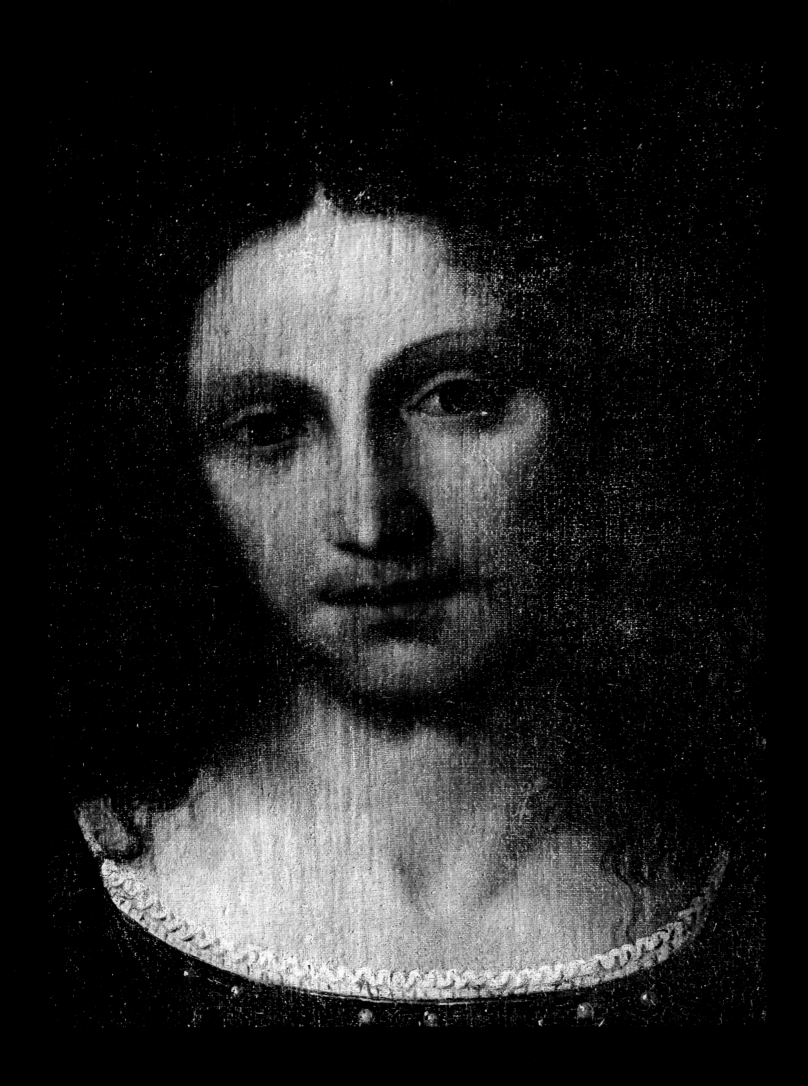

*A*nd Jesus increased in wisdom and stature, and in favor with God and man. LUKE 2:52

HIS MINISTRY

And it came to pass in those days, that Jesus came from Nazareth of Galilee, and was baptized of John in Jordan. And straightway coming up out of the water, he saw the heavens opened, and the Spirit like a dove descending upon him: And there came a voice from heaven, saying, Thou art my beloved Son, in whom I am well pleased. MARK 1:9–11

GIOTTO, *THE BAPTISM OF CHRIST BY ST. JOHN THE BAPTIST*

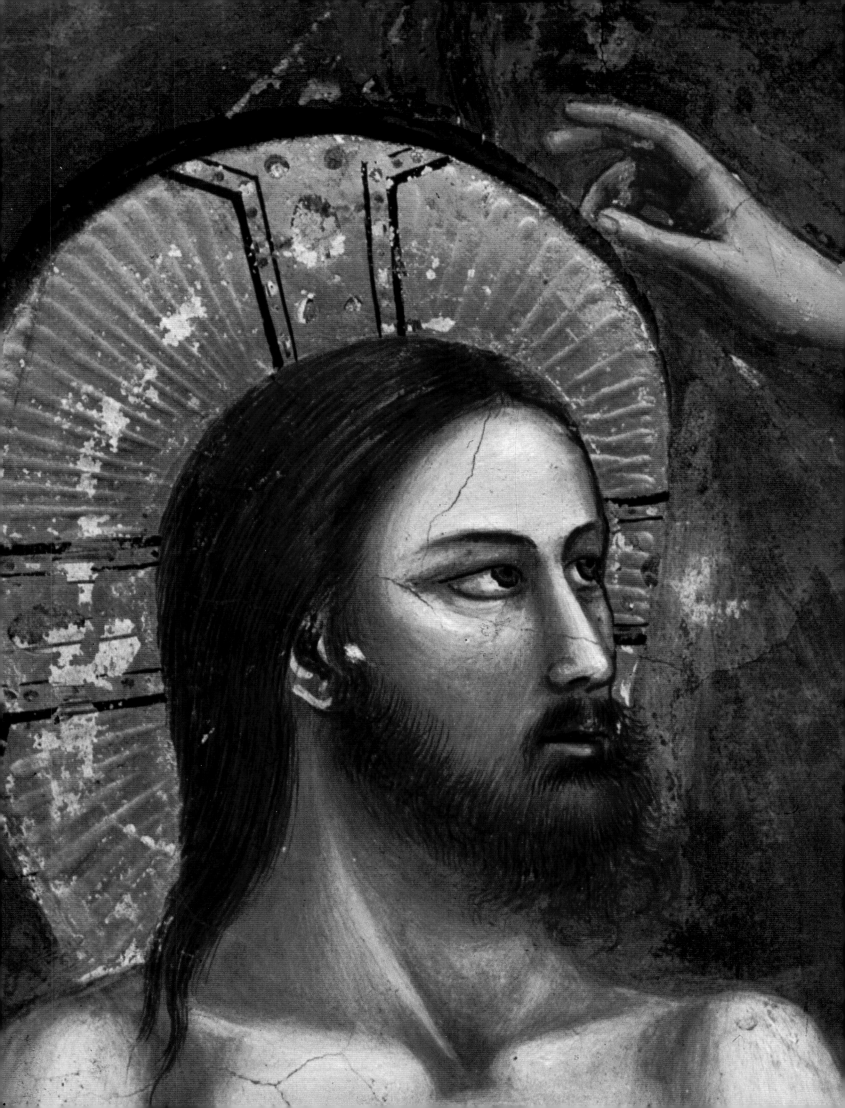

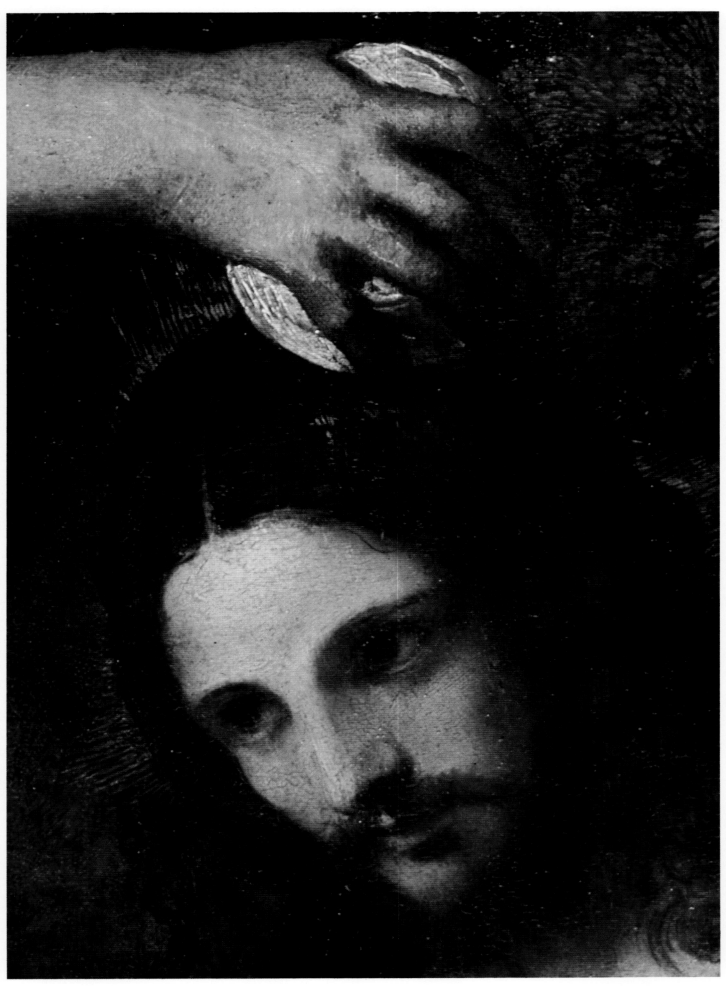

TITIAN, *BAPTISM OF CHRIST*

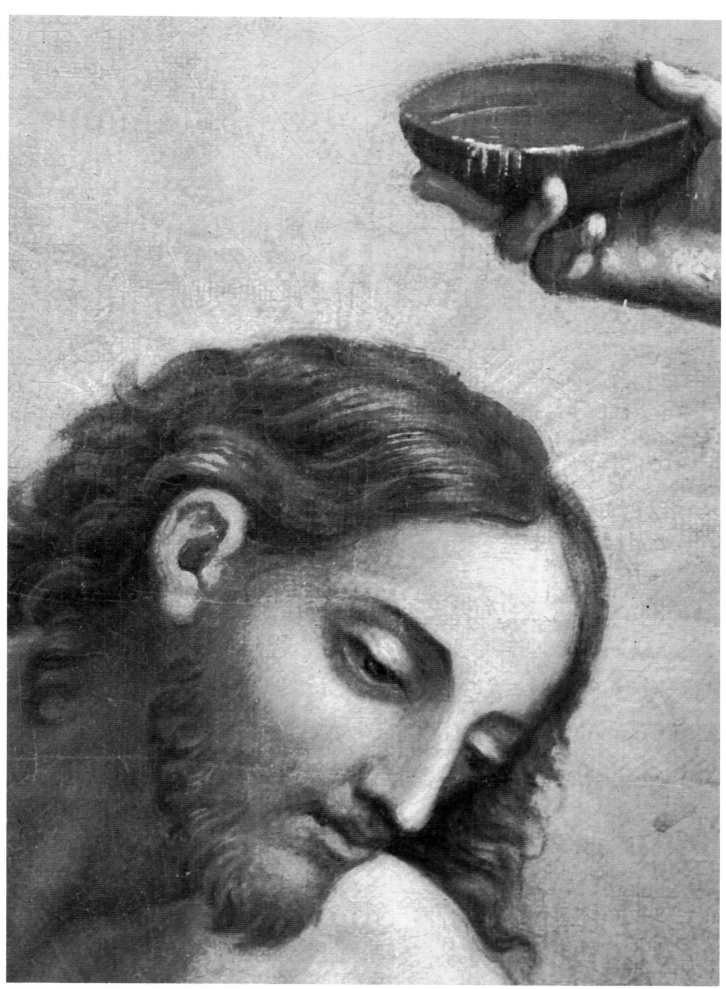

HENDRIK KROCK, *BAPTISM OF CHRIST*

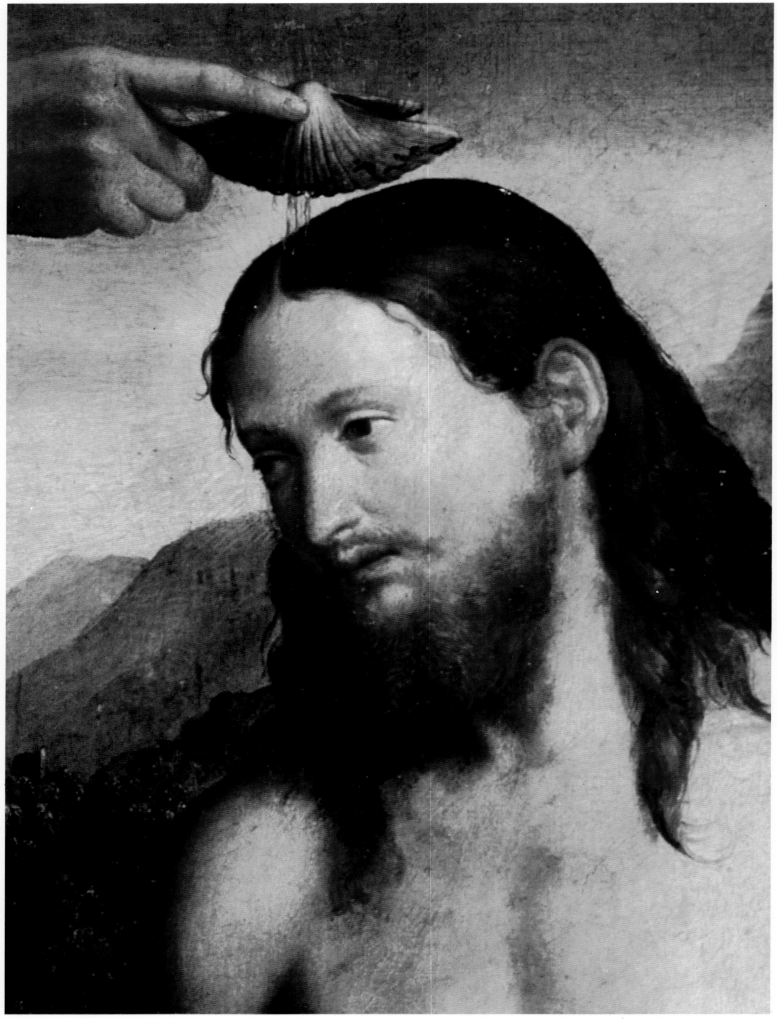

CALISTO PIAZZA, *BAPTISM OF CHRIST*

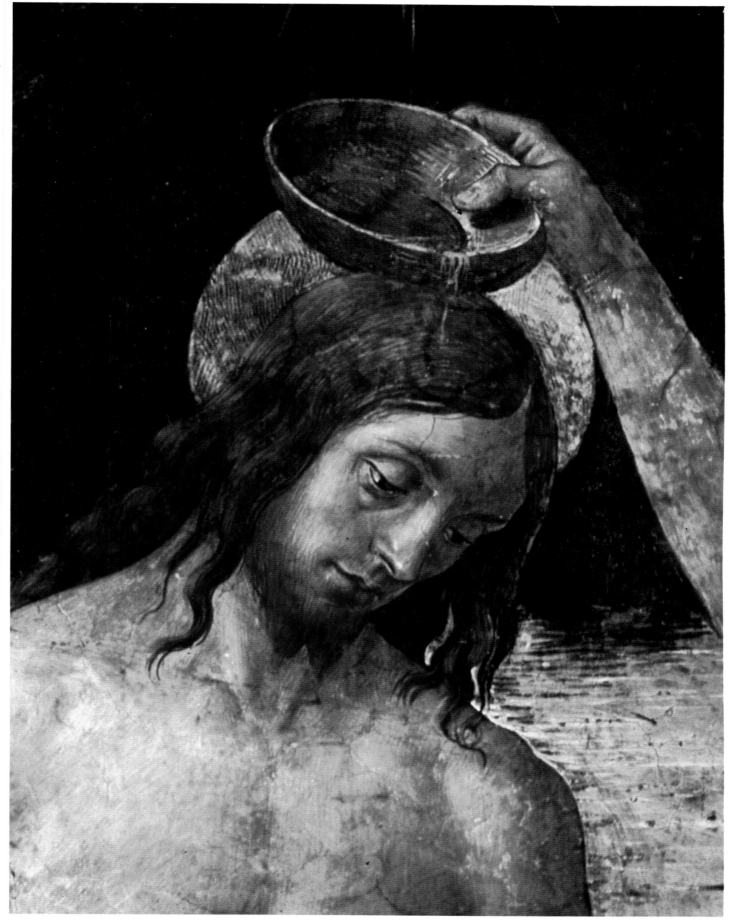

PERUGINO, *BAPTISM OF CHRIST*

*And Jesus returned in the power of the Spirit into Galilee:
and there went out a fame of him through all the region round
about.* LUKE 4:14

*A*nd he was there in the wilderness forty days
tempted of Satan; and was with the wild beasts;
and the angels ministered unto him. MARK 1:13

*G*ET THEE BEHIND ME, SATAN: FOR IT
IS WRITTEN, THOU SHALT WORSHIP
THE LORD THY GOD, AND HIM ONLY
SHALT THOU SERVE. JOHN 4:8

TITIAN, *TEMPTATION OF CHRIST*

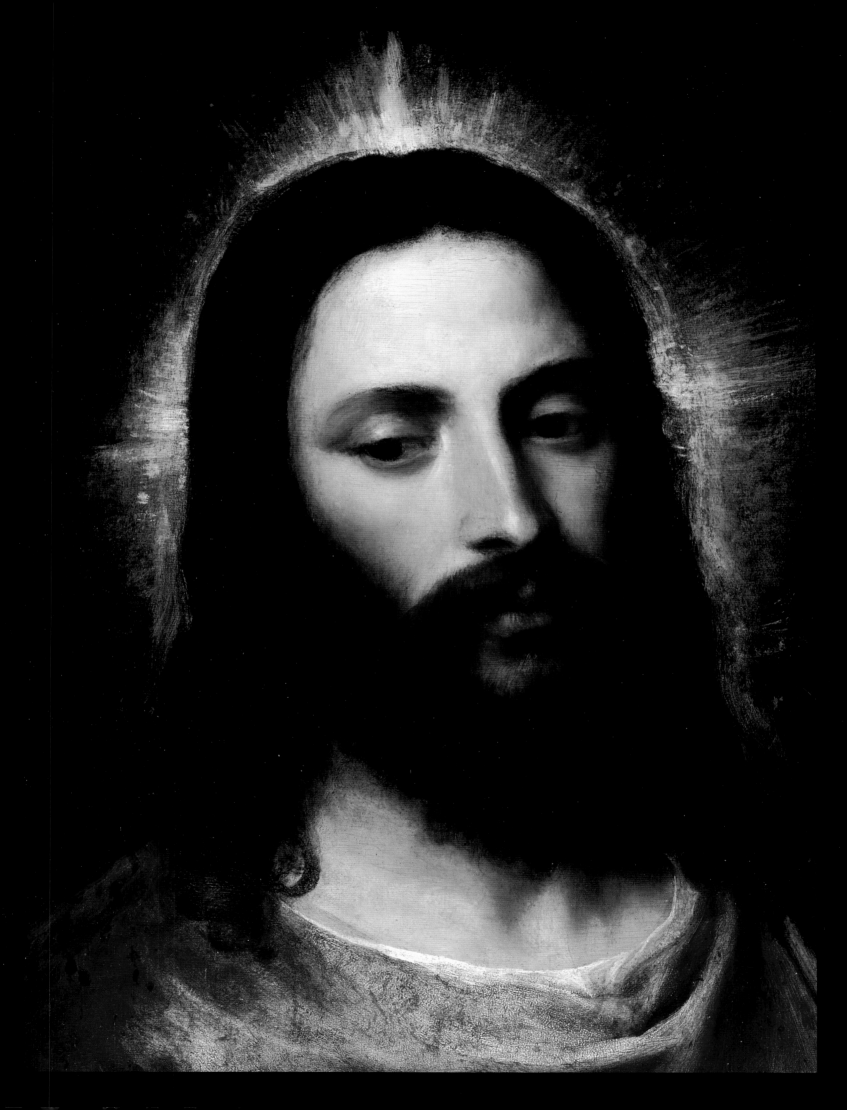

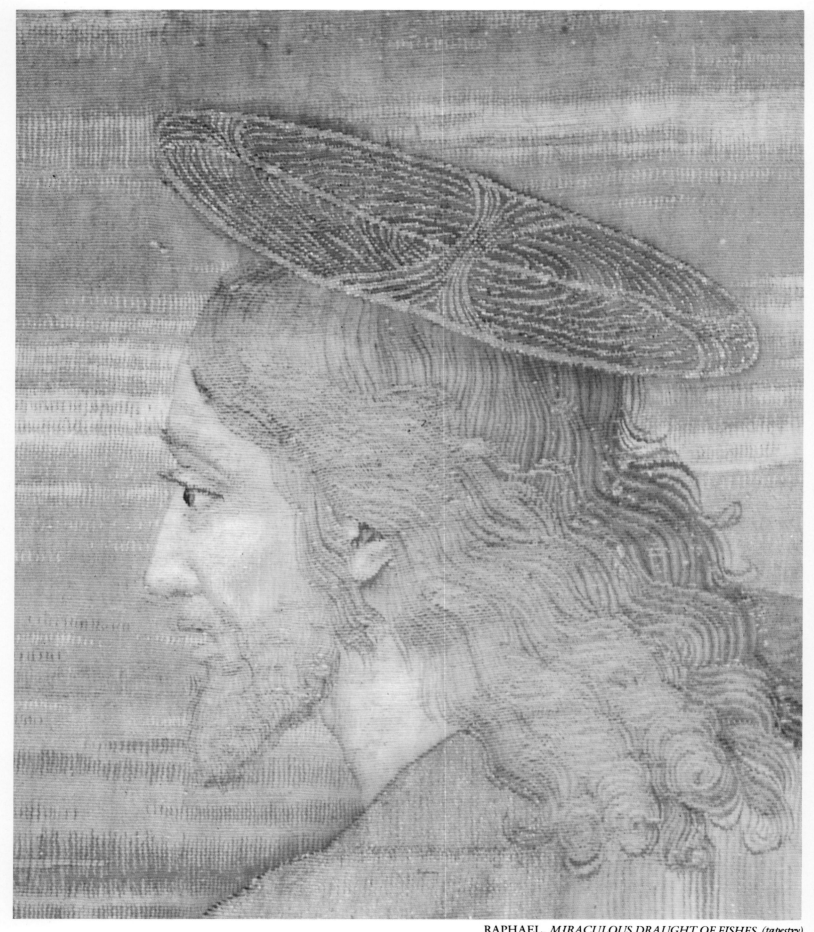

RAPHAEL, *MIRACULOUS DRAUGHT OF FISHES* *(tapestry)*

FOLLOW ME, AND I WILL MAKE YOU FISHERS OF MEN. MATTHEW 4:19–20

DUCCIO, *THE CALLING OF THE APOSTLES PETER AND ANDREW*

*A*nd Jesus went about all Galilee, teaching in their synagogues, and preaching the gospel of the kingdom, and healing all manner of sickness and all manner of disease among the people. MATTHEW 5:23

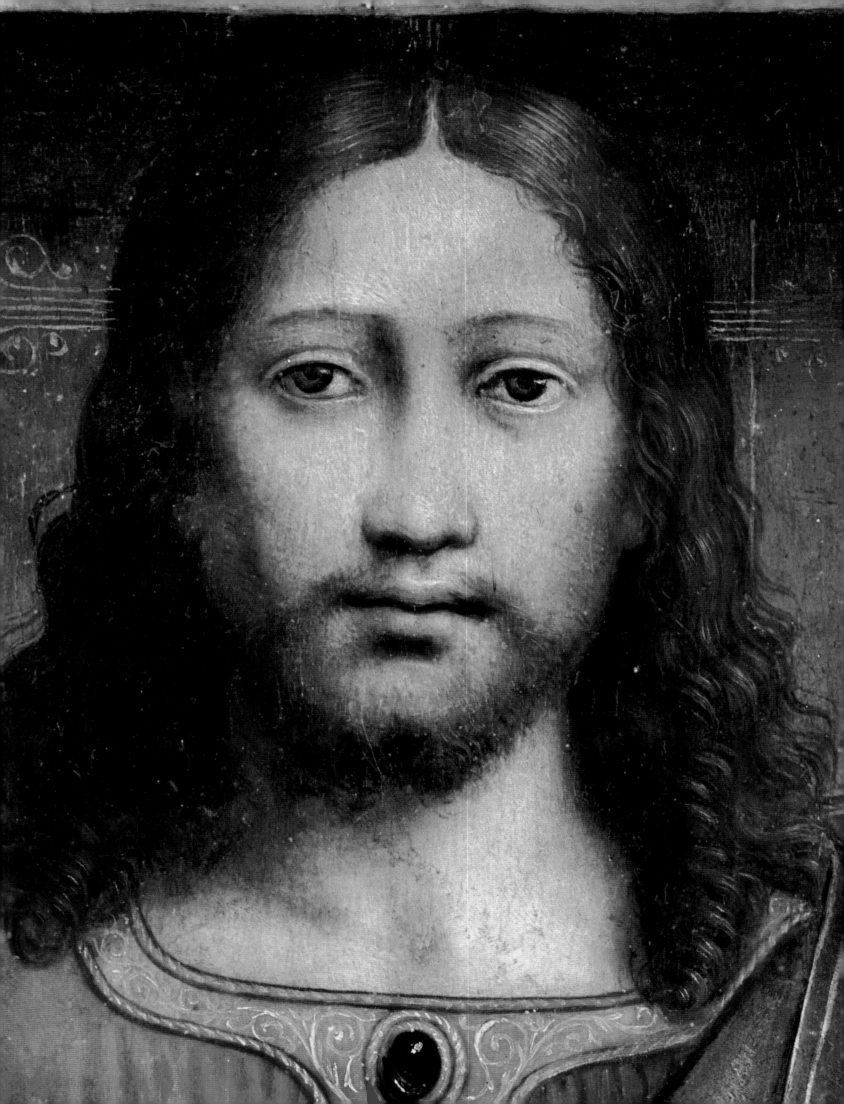

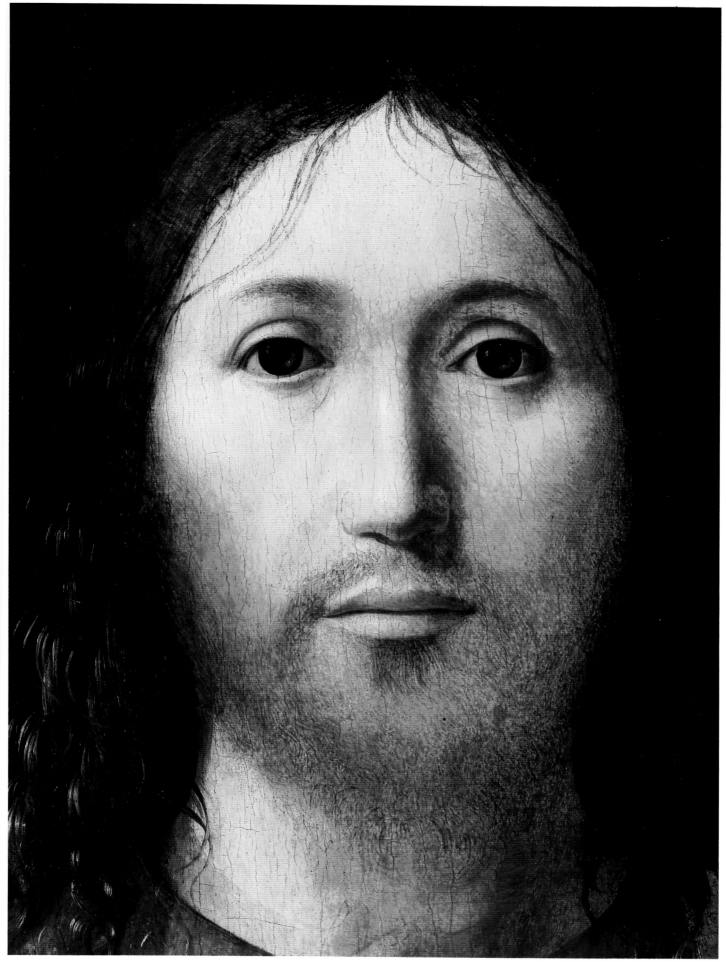

ANTONELLA DA MESSINA, *SALVATOR MUNDI*

GIAN PIETRO RIZZI, *THE REDEEMER*

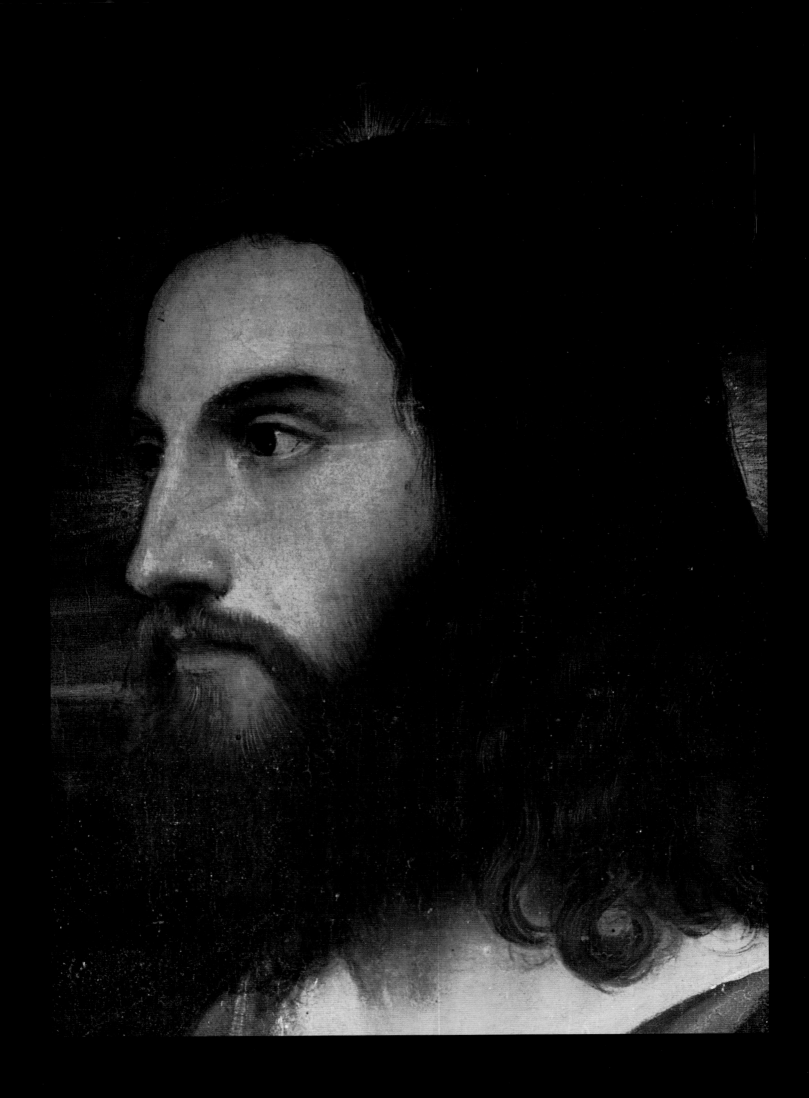

And seeing the multitudes, he went up into a mountain:
and when he was set, his disciples came unto him:
And he opened his mouth, and taught them, saying,

BLESSED ARE THE POOR IN SPIRIT: FOR THEIRS IS THE KINGDOM OF HEAVEN.

BLESSED ARE THEY THAT MOURN: FOR THEY SHALL BE COMFORTED.

BLESSED ARE THE MEEK: FOR THEY SHALL INHERIT THE EARTH.

BLESSED ARE THEY WHICH DO HUNGER AND THIRST AFTER RIGHTEOUSNESS: FOR THEY
SHALL BE FILLED.

BLESSED ARE THE MERCIFUL: FOR THEY SHALL OBTAIN MERCY.

BLESSED ARE THE PURE IN HEART: FOR THEY SHALL SEE GOD.

BLESSED ARE THE PEACEMAKERS: FOR THEY SHALL BE CALLED THE CHILDREN OF GOD.

BLESSED ARE THEY WHICH ARE PERSECUTED FOR RIGHTEOUSNESS' SAKE:
FOR THEIRS IS THE KINGDOM OF HEAVEN.

BLESSED ARE YE, WHEN MEN SHALL REVILE YOU, AND PERSECUTE YOU, AND
SHALL SAY ALL MANNER OF EVIL AGAINST YOU FALSELY, FOR MY SAKE.

REJOICE, AND BE EXCEEDING GLAD: FOR GREAT IS YOUR REWARD IN HEAVEN: FOR SO
PERSECUTED THEY THE PROPHETS WHICH WERE BEFORE YOU. MATTHEW 5:2–13

TITIAN, *HEAD OF CHRIST*

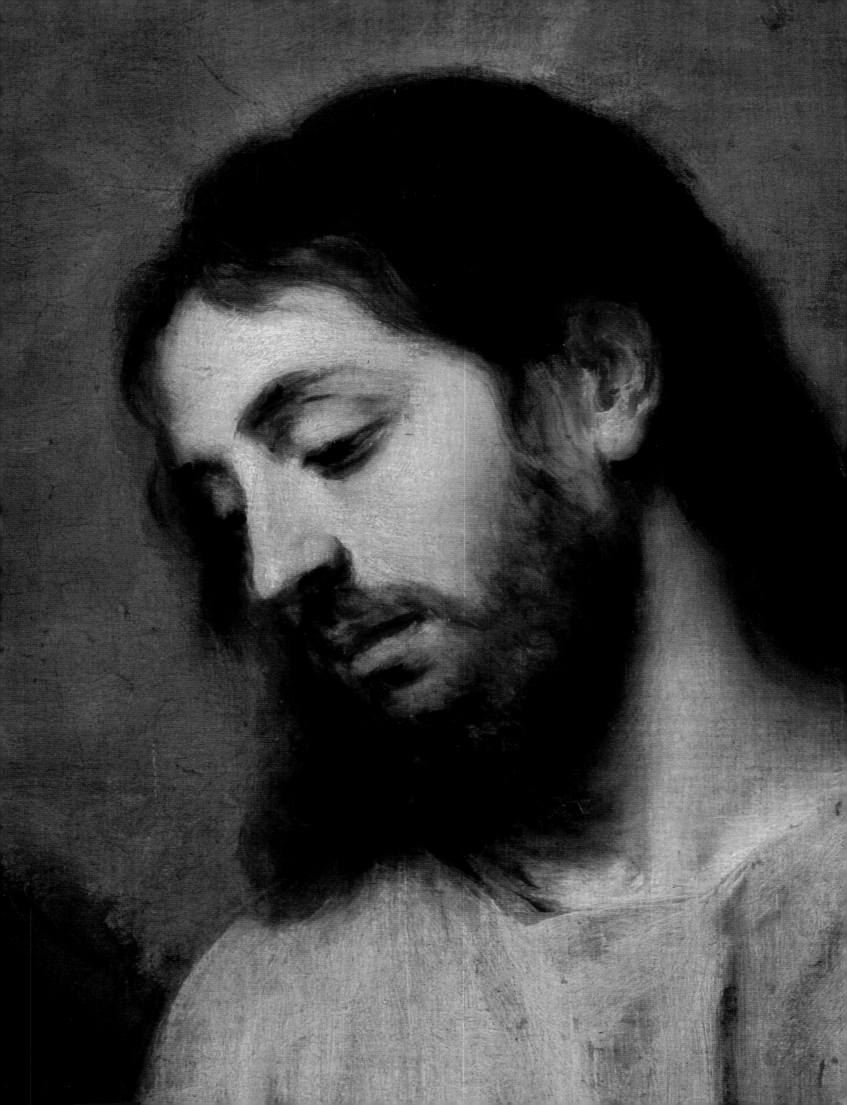

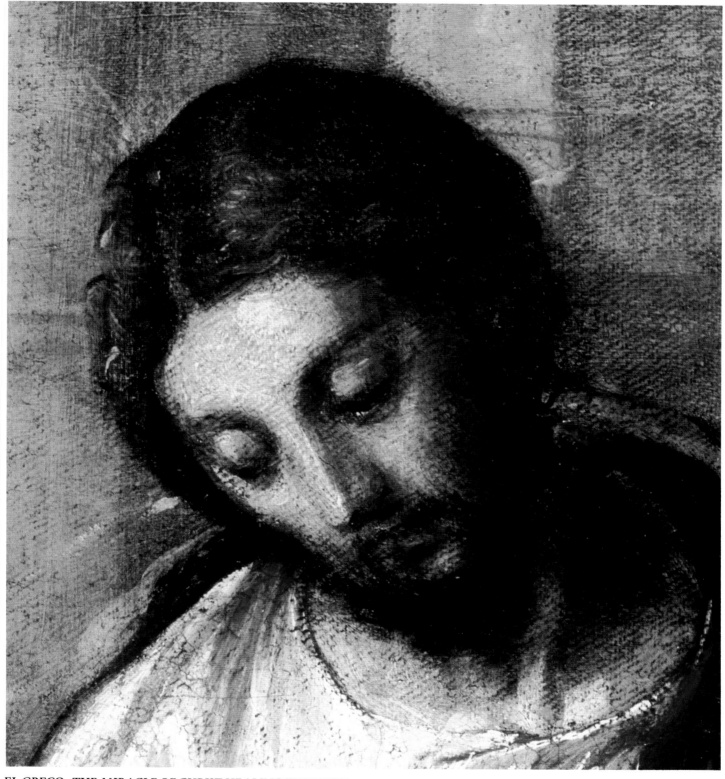

EL GRECO, *THE MIRACLE OF CHRIST HEALING THE BLIND*

VERILY, VERILY, I SAY UNTO YOU, THE HOUR IS COMING, AND NOW IS, WHEN THE DEAD SHALL HEAR THE VOICE OF THE SON OF GOD: AND THEY THAT HEAR SHALL LIVE. JOHN 5:25

FOR JUDGMENT I AM COME INTO THIS WORLD, THAT THEY WHICH SEE NOT MIGHT SEE; AND THAT THEY WHICH SEE MIGHT BE MADE BLIND. JOHN 9:39

BARTOLOMÉ ESTEBÁN MURILLO, *CHRIST HEALING THE PARALYTIC AT THE POOL OF BETHESDA*

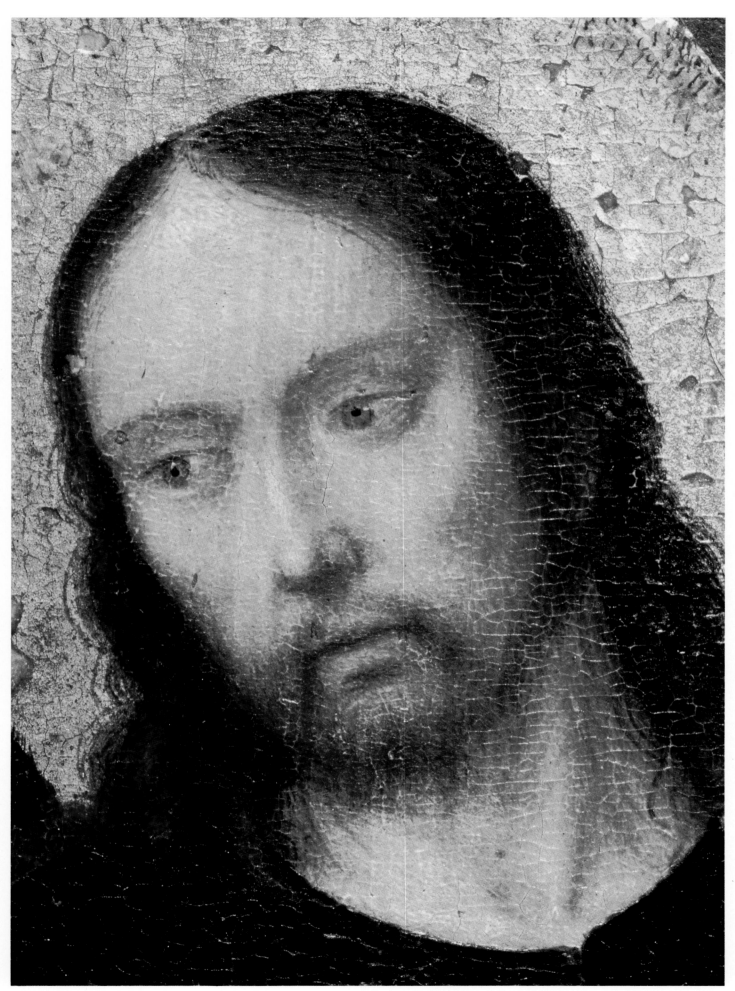

GERARD DAVID, *CHRIST TAKING LEAVE OF HIS MOTHER*

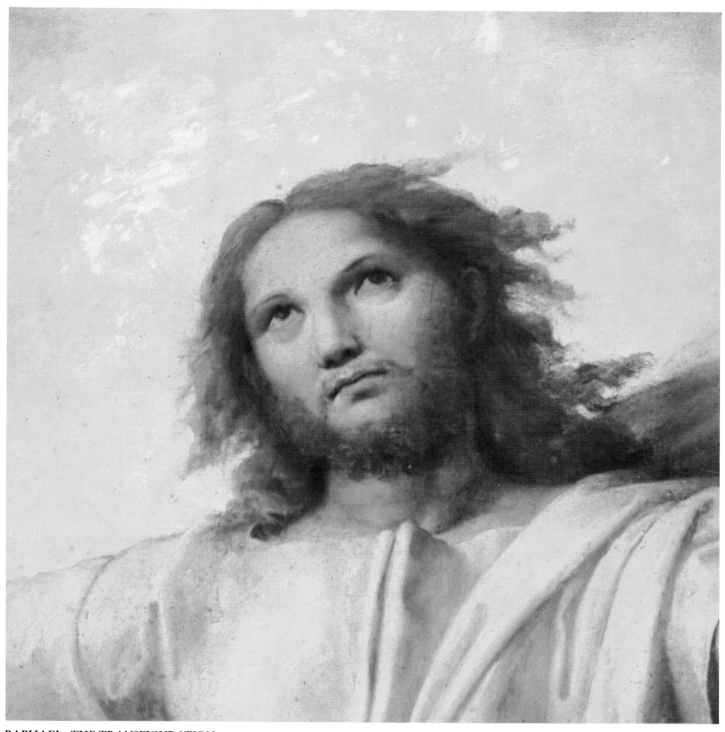

RAPHAEL, *THE TRANSFIGURATION*

And after six days Jesus taketh Peter, James, and John his brother, and bringth them up into an high mountain apart, and was transfigured before them: and his face did shine as the sun, and his raiment was white as the light. MATTHEW 17:1–2

VERILY I SAY UNTO YOU, EXCEPT YE BE CONVERTED, AND BECOME AS LITTLE CHILDREN, YE SHALL NOT ENTER INTO THE KINGDOM OF HEAVEN. WHOSOEVER THEREFORE SHALL HUMBLE HIMSELF AS THIS LITTLE CHILD, THE SAME IS GREATEST IN THE KINGDOM OF HEAVEN. AND WHOSO SHALL RECEIVE ONE SUCH LITTLE CHILD IN MY NAME RECEIVETH ME. MATTHEW 18:2–5

NICOLAES MAES, *CHRIST BLESSING THE CHILDREN*

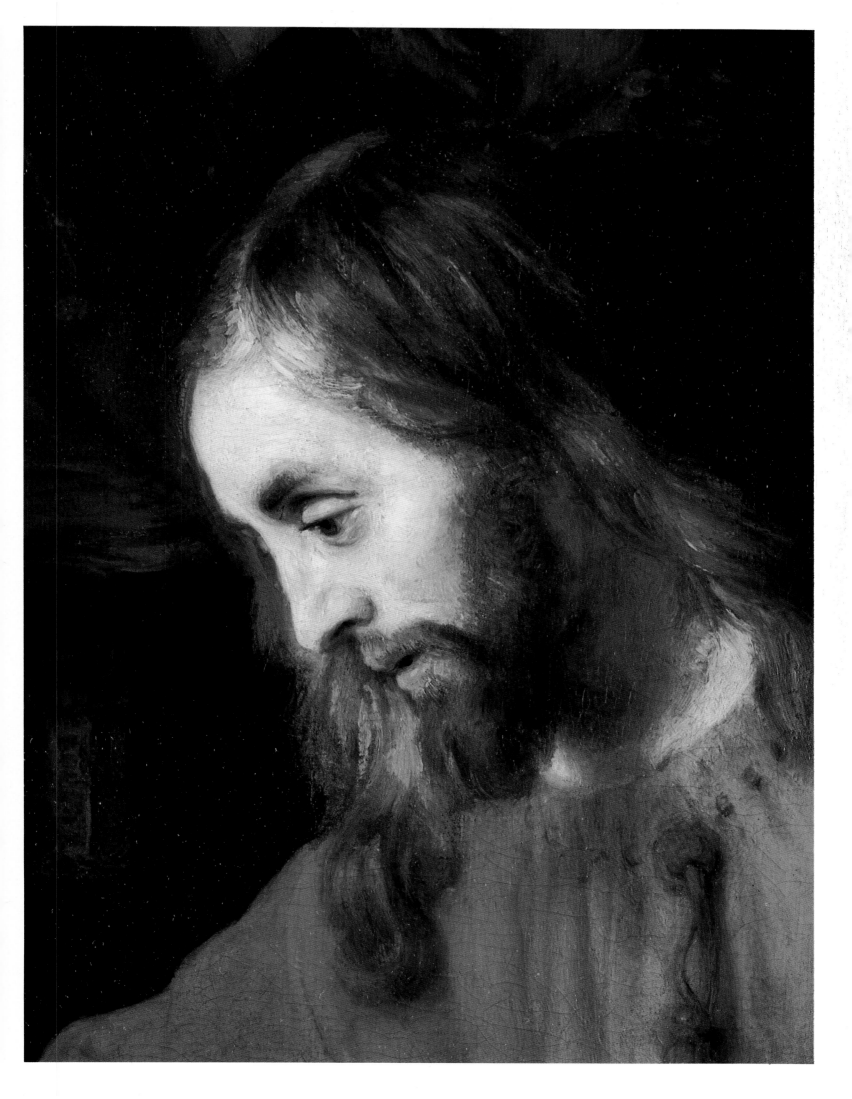

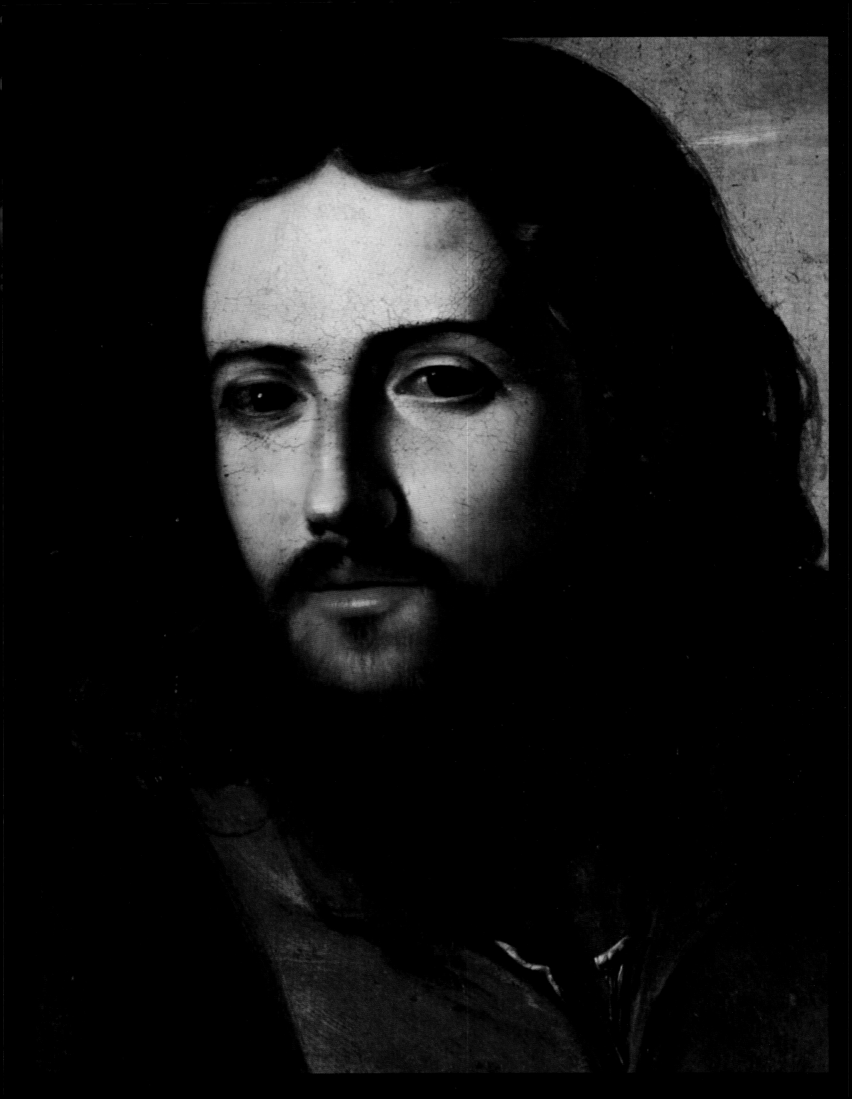

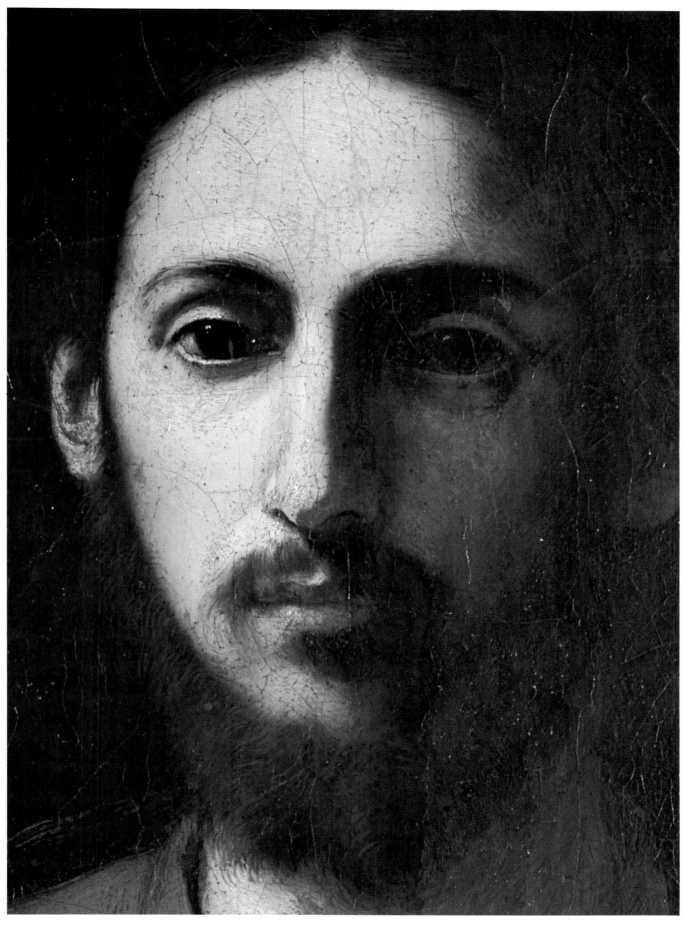

JOSÉ DE RIBERA, *THE SAVIOR*

*S*UFFER LITTLE CHILDREN, AND FORBID THEM NOT, TO
COME UNTO ME: FOR OF SUCH IS THE KINGDOM OF
HEAVEN. MATTHEW 19:14

PACECCO DE ROSA, *CHRIST BLESSING THE CHILDREN*

It is written, my house shall be called the house of prayer: but ye have made it a den of thieves.

MATTHEW 21:13

EL GRECO, *CHRIST DRIVING THE MONEY CHANGERS FROM THE TEMPLE*

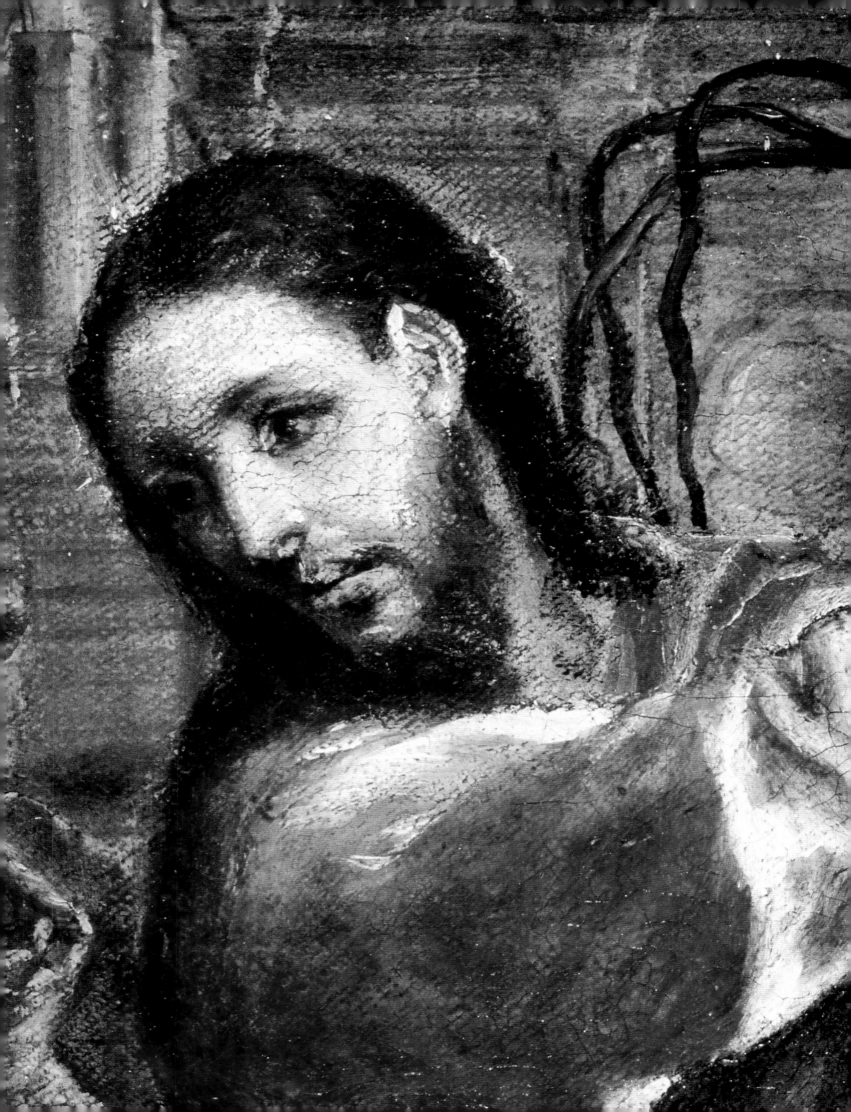

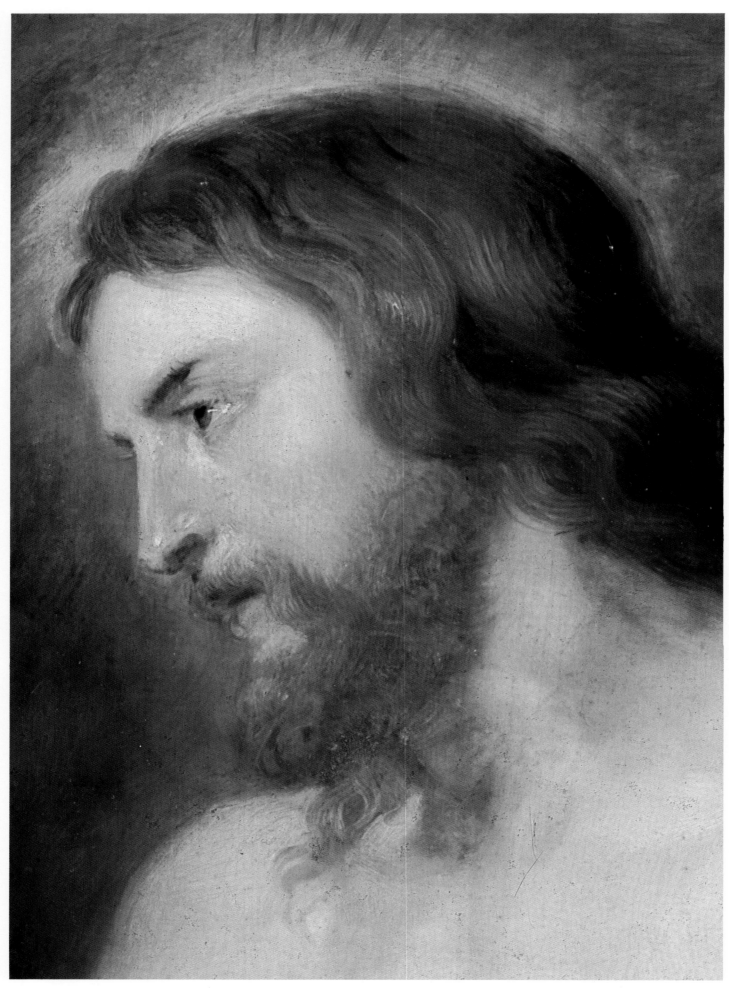

PETER PAUL RUBENS, *CHRIST AND MARY MAGDALEN*

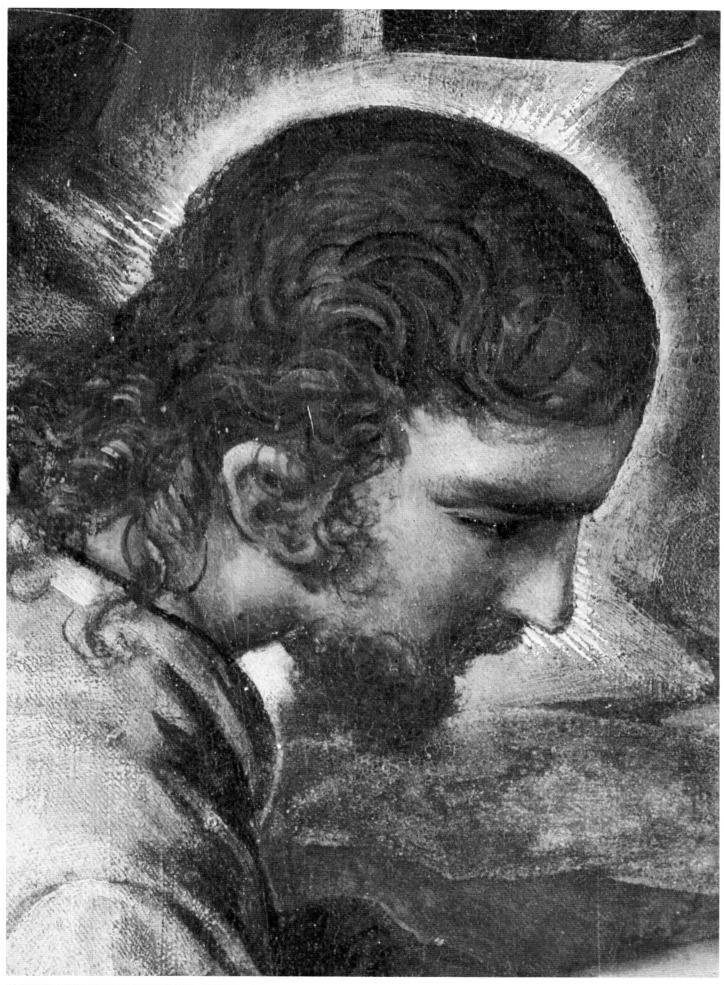

JACOPO ROBUSTI TINTORETTO, *CHRIST AT THE HOME OF MARY AND MARTHA*

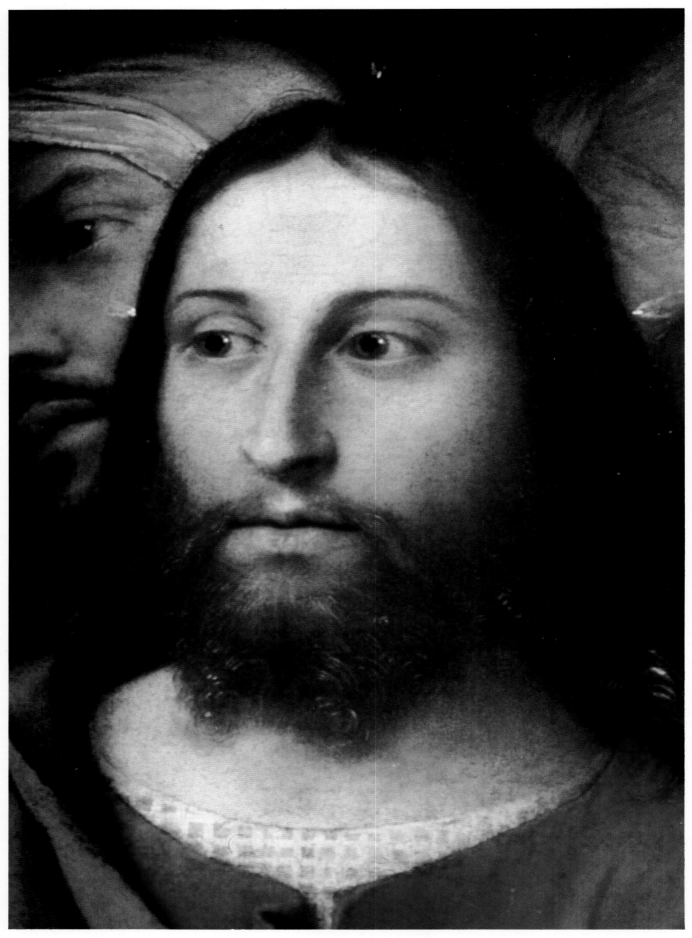

LORENZO LOTTO, *CHRIST AND THE WOMAN TAKEN IN ADULTERY*

I AM THE LIGHT OF THE WORLD: HE THAT FOLLOWETH ME SHALL NOT WALK IN DARKNESS, BUT SHALL HAVE THE LIGHT OF LIFE. JOHN 8:12

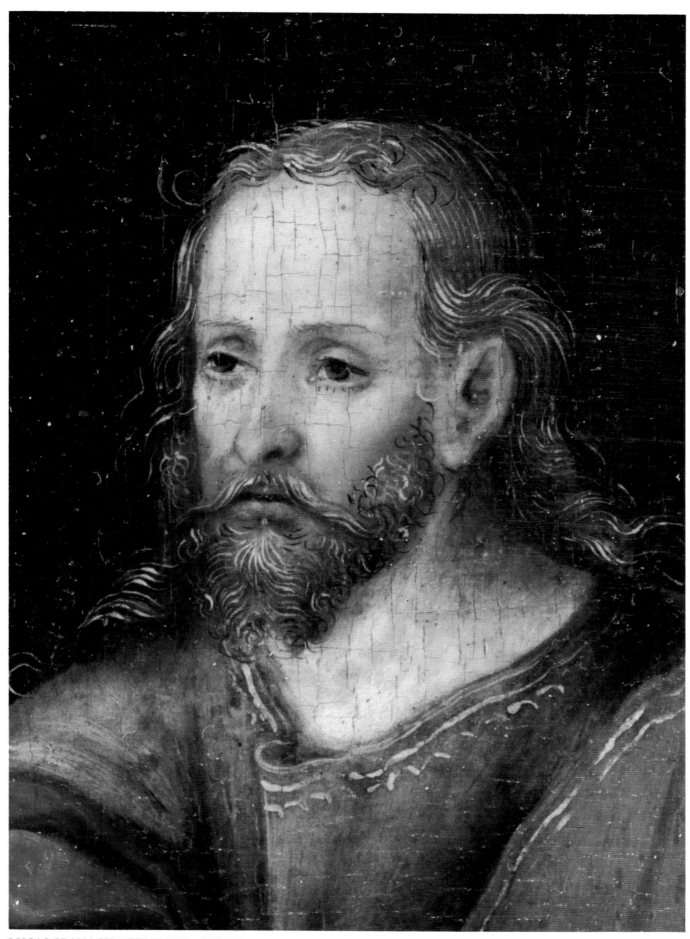

LUCAS CRANACH, THE ELDER, *CHRIST AND THE ADULTERESS*

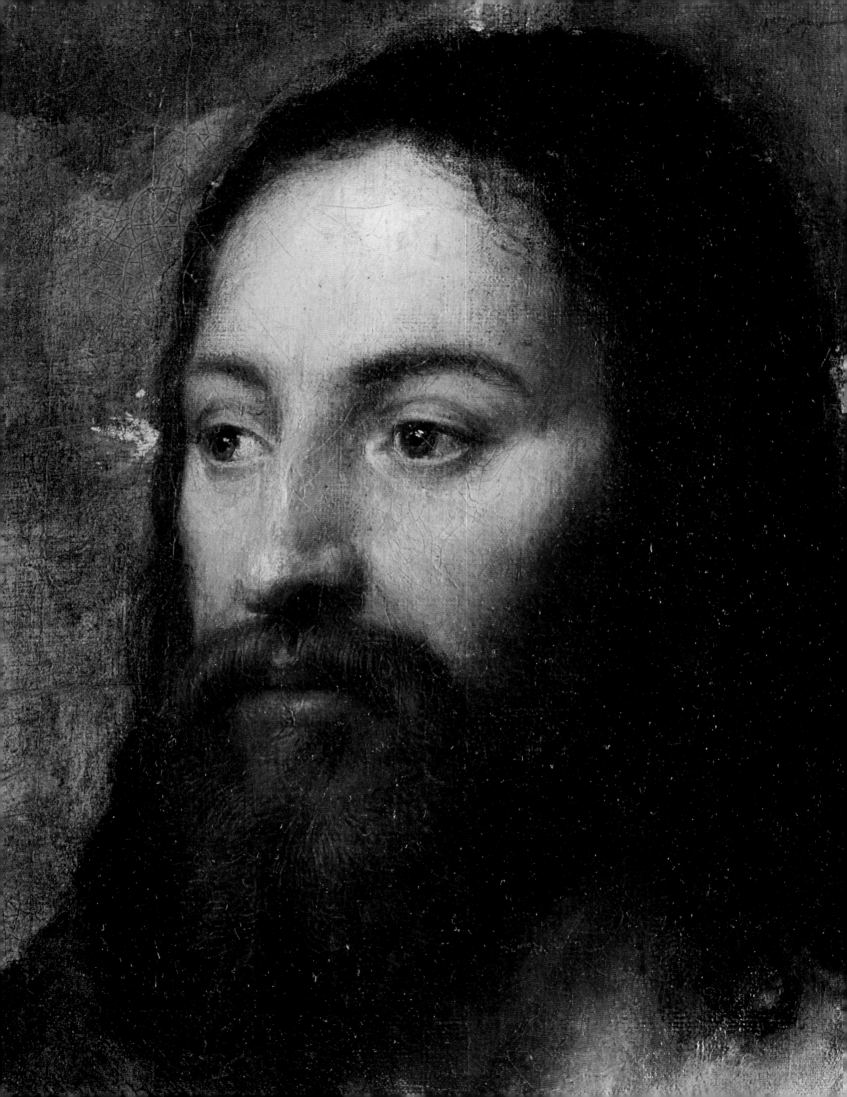

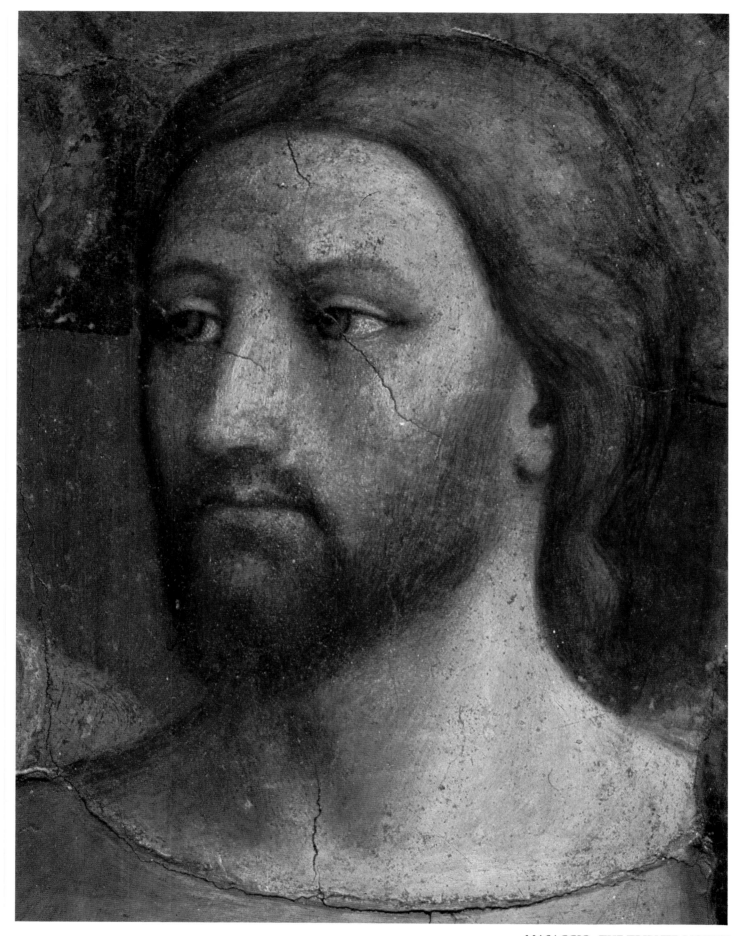

*R*ENDER THEREFORE UNTO CAESAR THE THINGS WHICH ARE CAESAR'S; AND UNTO GOD
THE THINGS THAT ARE GOD'S. MATTHEW 23:21

TITIAN, *THE TRIBUTE MONEY*

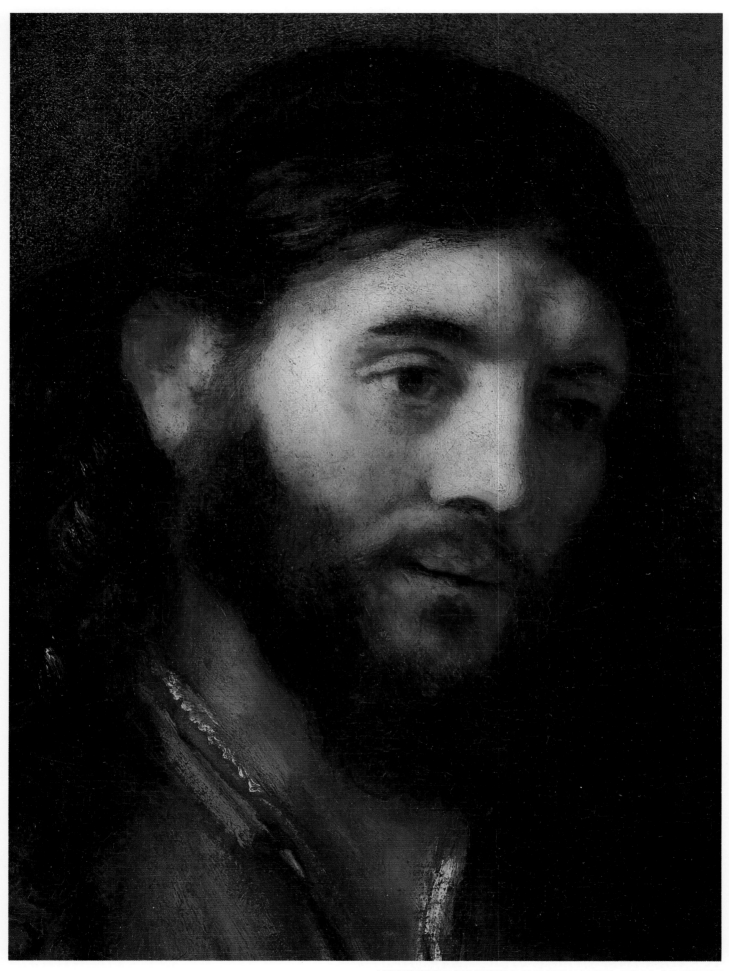

ATTRIBUTED TO REMBRANDT VAN RYN, *HEAD OF CHRIST*

I AM THE GOOD SHEPHERD, AND KNOW MY SHEEP, AND AM KNOWN OF MINE. AS THE FATHER KNOWETH ME, EVEN SO I KNOW THE FATHER: AND I LAY DOWN MY LIFE FOR THE SHEEP. JOHN 10:14–15

HIS SUFFERING

*A*nd as they did eat, Jesus took bread, and blessed, and brake it, and gave to them, and said, TAKE, EAT: THIS IS MY BODY. And he took the cup, and when he had given thanks, he gave it to them: and they all drank of it. And he said unto them, THIS IS MY BLOOD OF THE NEW TESTAMENT, WHICH IS SHED FOR MANY. MARK 14:22–24

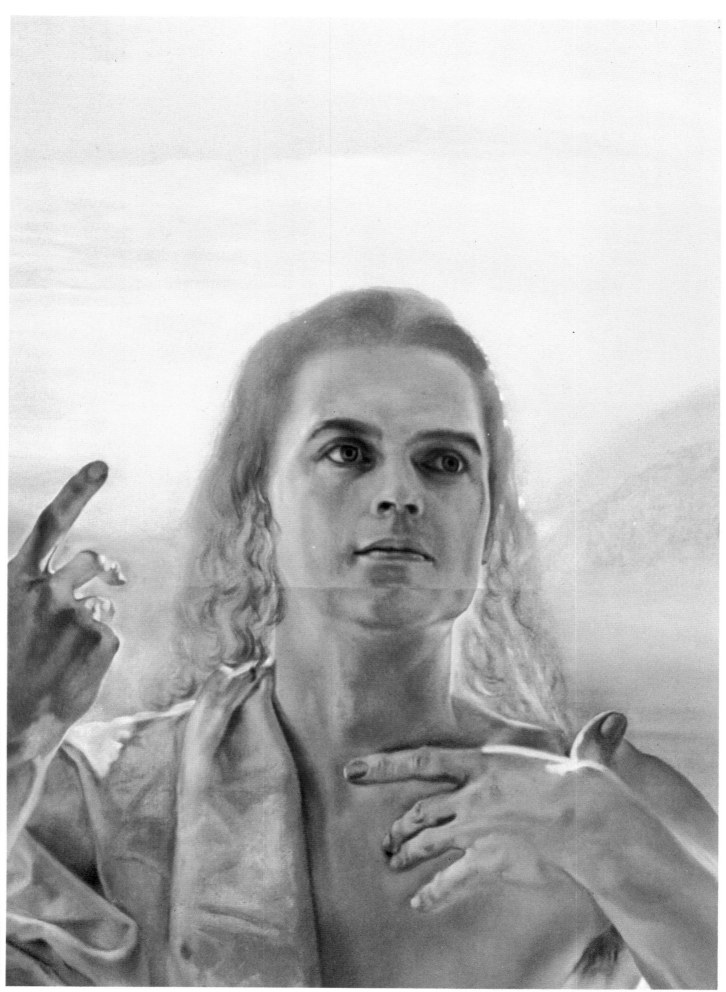

SALVADOR DALI, *THE SACRAMENT OF THE LAST SUPPER*

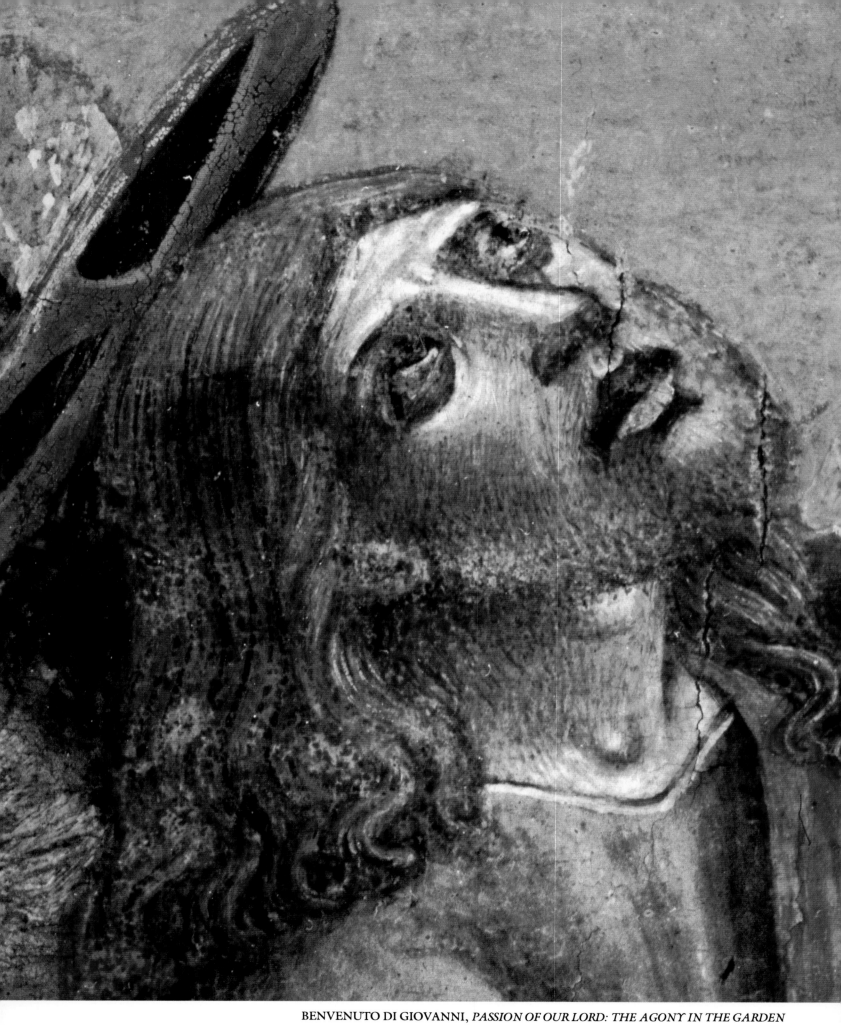

BENVENUTO DI GIOVANNI, *PASSION OF OUR LORD: THE AGONY IN THE GARDEN*

*FATHER, IF THOU BE WILLING, REMOVE THIS CUP FROM ME:
NEVERTHELESS NOT MY WILL, BUT THINE, BE DONE.* LUKE 22:42

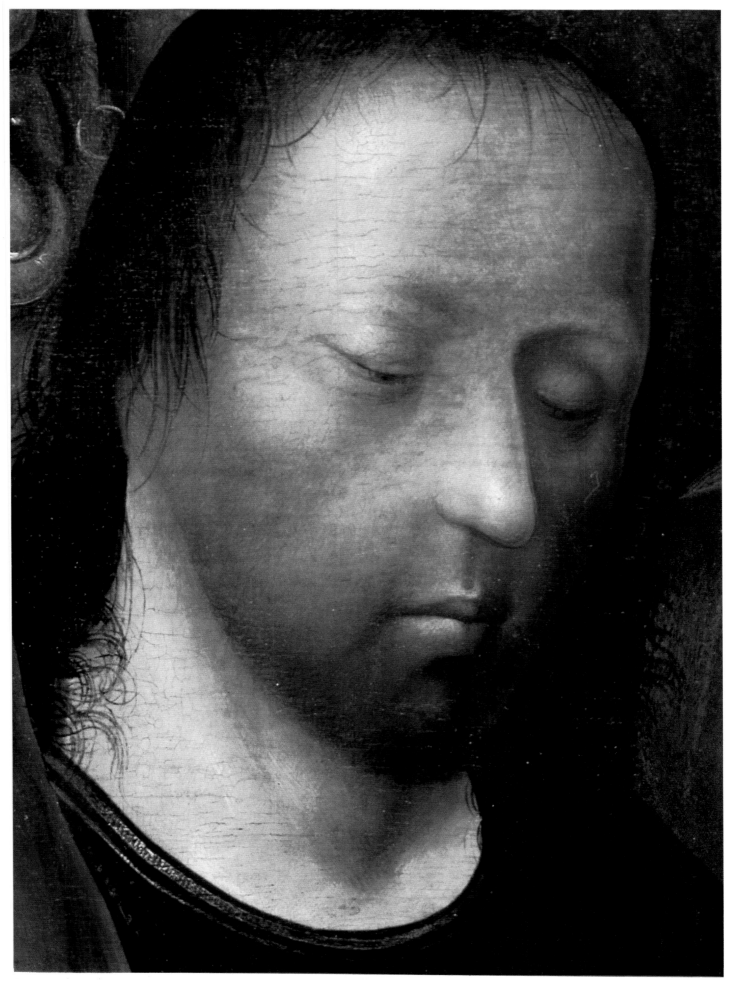

HIERONYMUS BOSCH, *CHRIST BEFORE PILATE*

*A*nd when they had bound him, they led him away, and delivered
him to Pontius Pilate the governor. MATTHEW 27:2

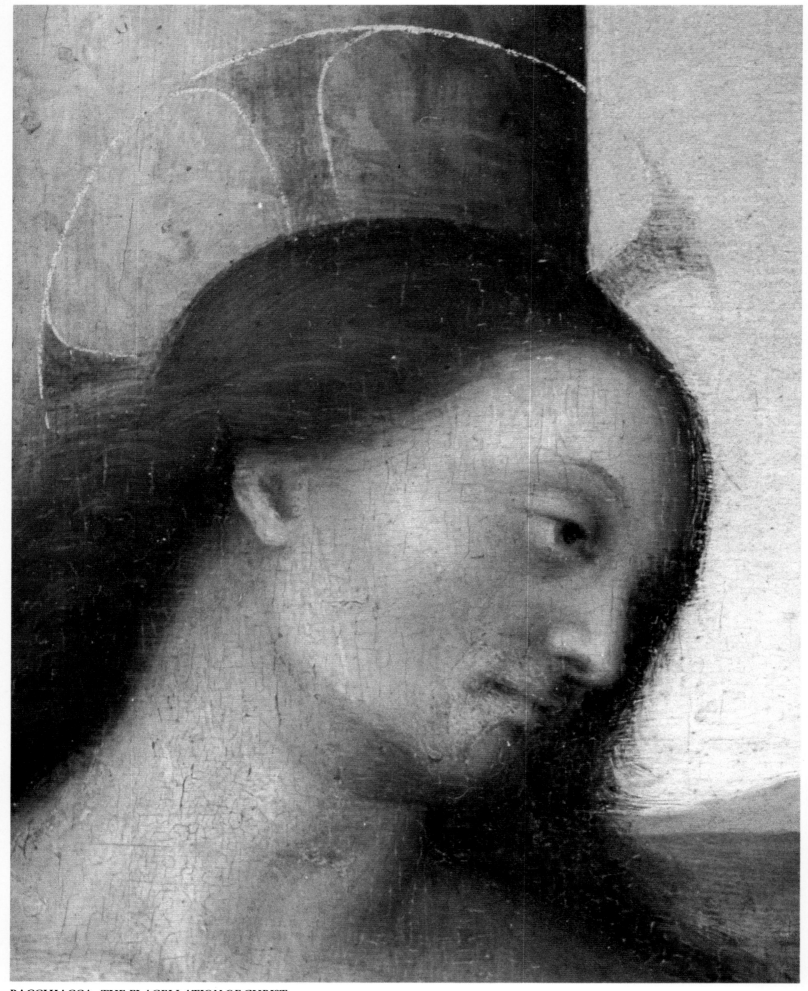

BACCHIACCA, *THE FLAGELLATION OF CHRIST*

Then Pilate therefore took Jesus, and scourged him. JOHN 19:1

72

DIEGO RODRIGUEZ VELAZQUEZ, *CHRIST AFTER THE FLAGELLATION CONTEMPLATED BY THE CHRISTIAN SOUL*

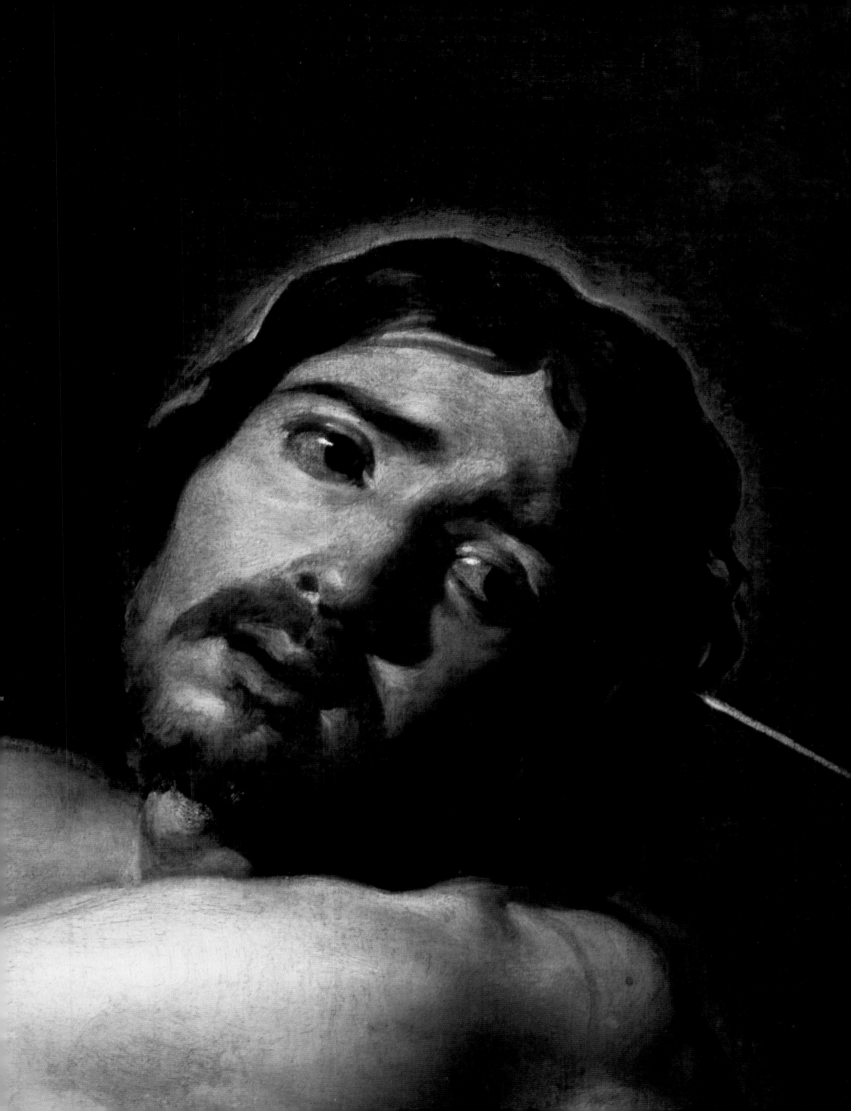

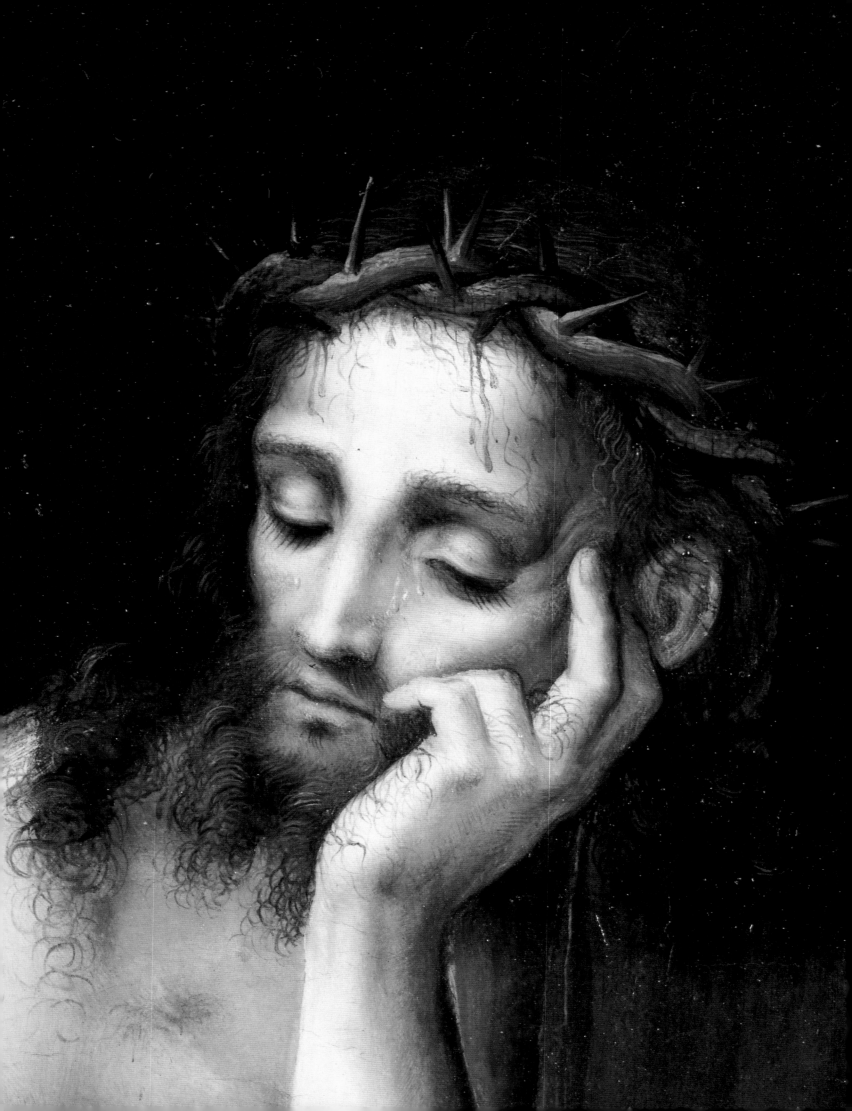

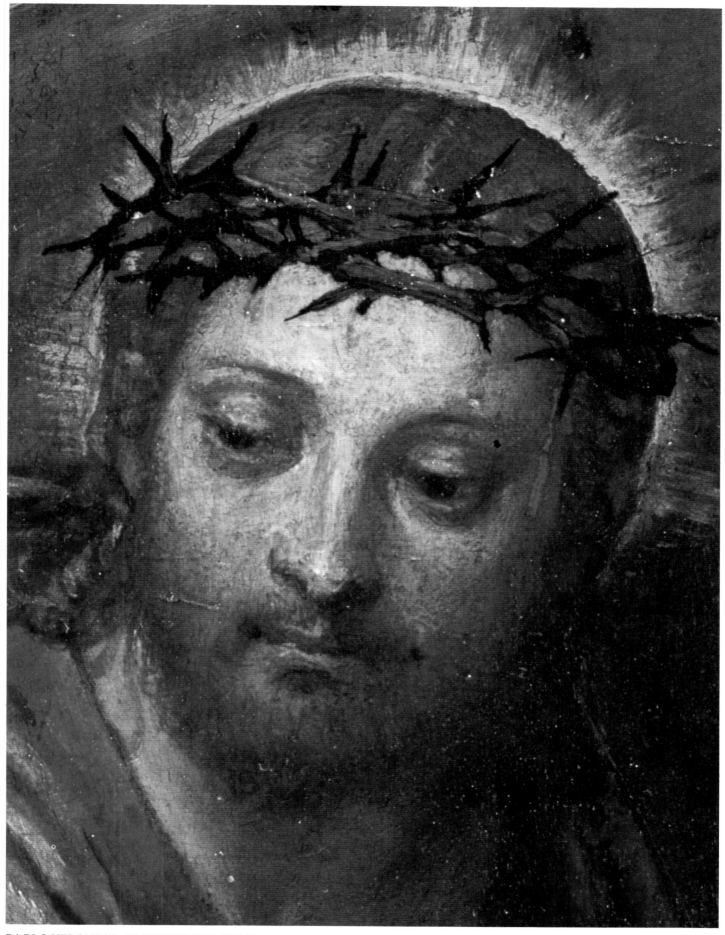

PAOLO VERONESE, *CARRYING THE CROSS*

*A*nd the soldiers platted a crown of thorns, and put it on
his head, and they put on him a purple robe, and said, Hail,
King of the Jews! JOHN 19:2–3

LUIS DE MORALES, *MAN OF SORROWS*

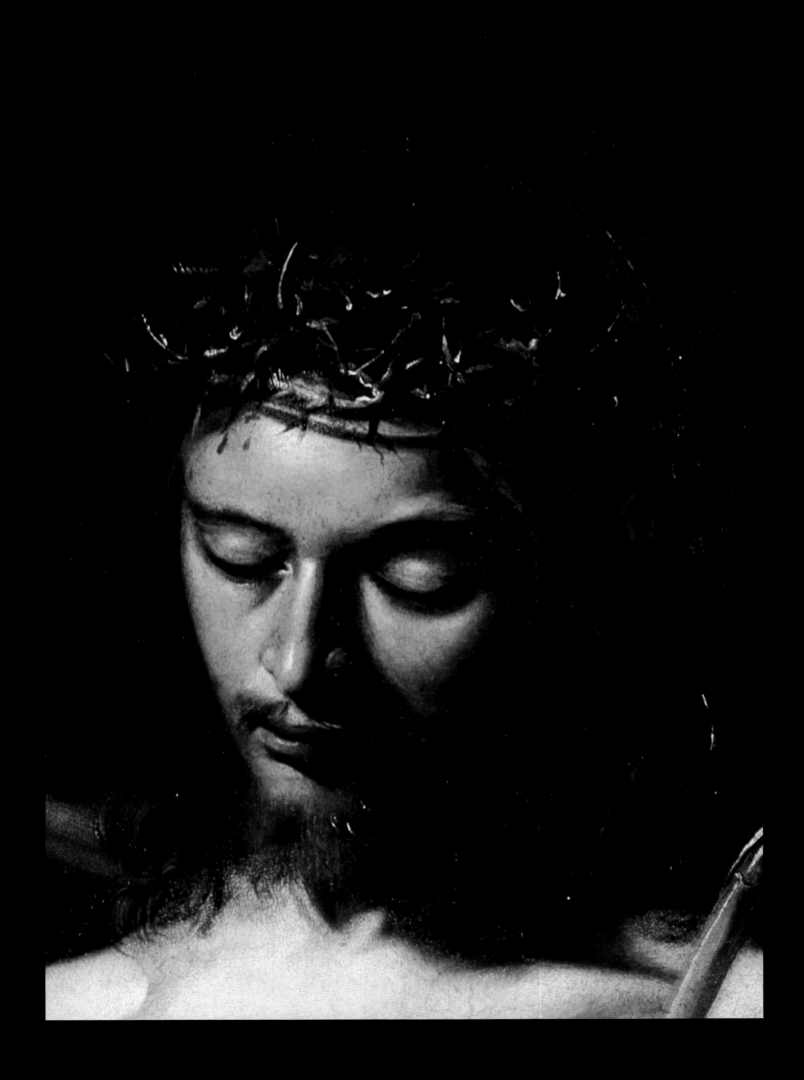

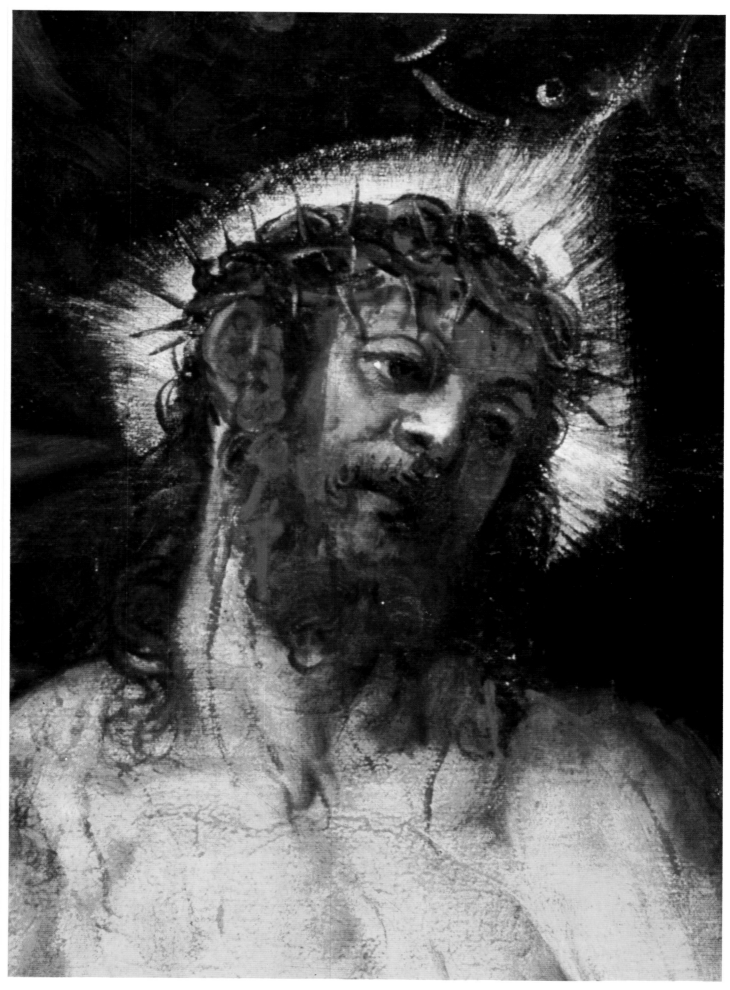

TINTORETTO, *ECCE HOMO*

MICHELANGELO CARAVAGGIO, *ECCE HOMO*

*A*nd they smote him on the head with a reed, and did spit upon him, and bowing their knees worshipped him. And when they had mocked him, they took off the purple from him, and put his own clothes on him, and led him out to crucify him. MARK 15:19–20

ANTHONY VAN DYCK, *THE MOCKING OF CHRIST*

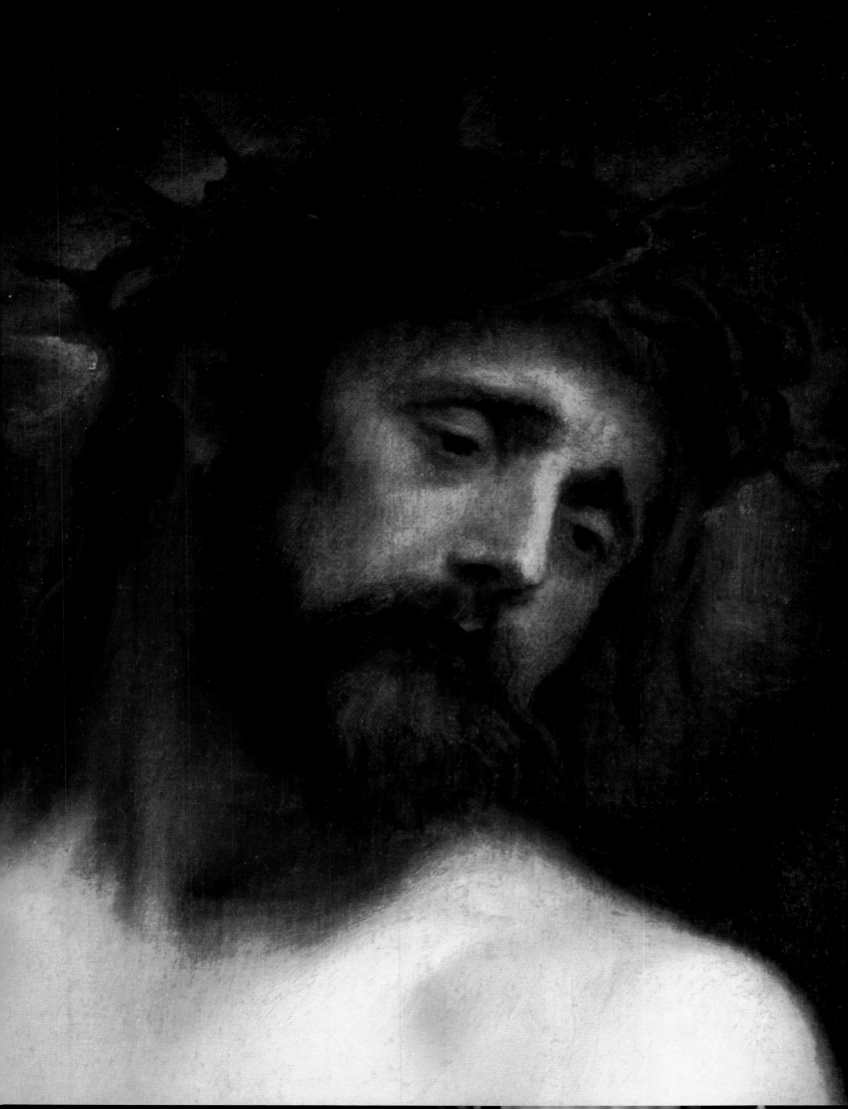

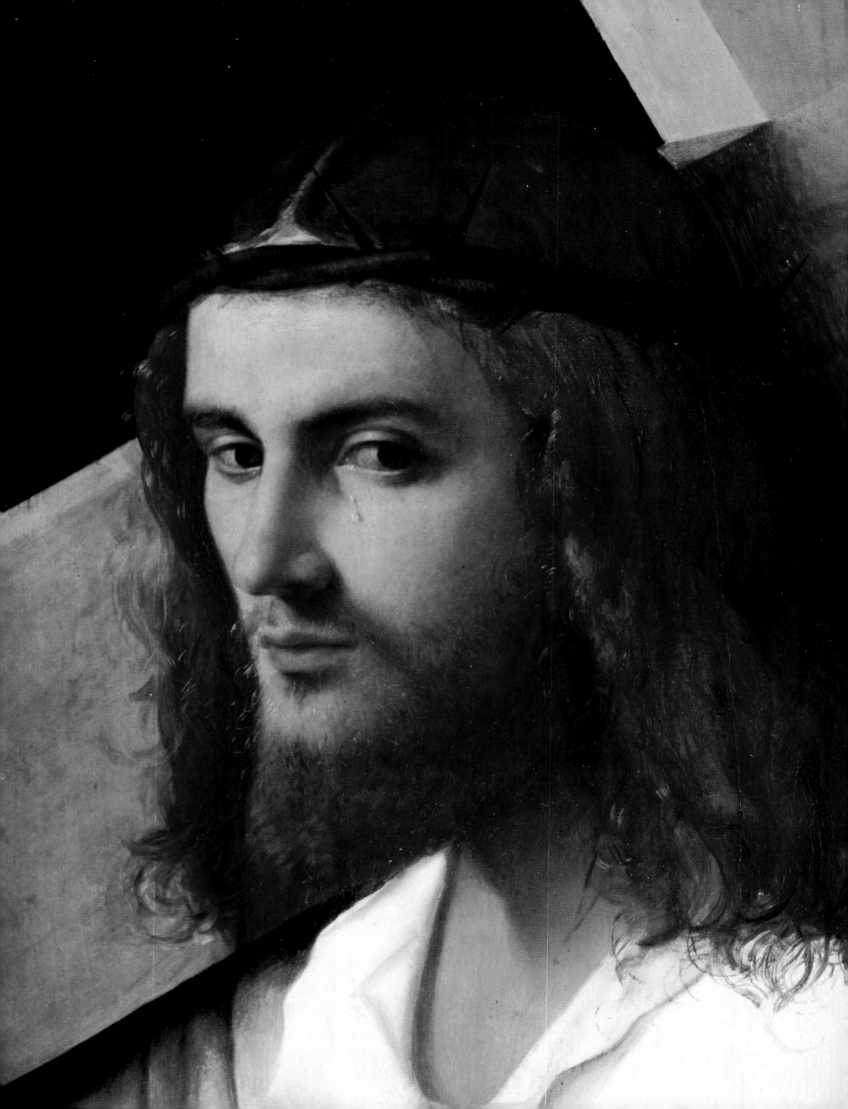

*A*nd there followed him a great company of people, and of women, which also bewailed and lamented him. LUKE 23:26–27

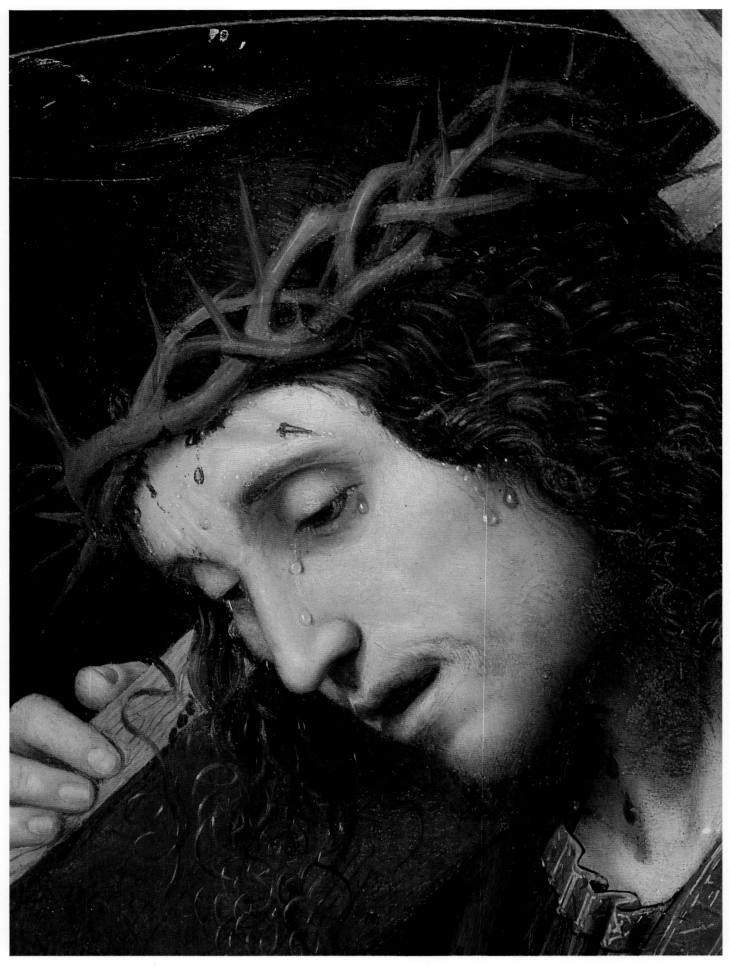

GIAN FRANCESCO DE MAINERI, *CHRIST CARRYING THE CROSS*

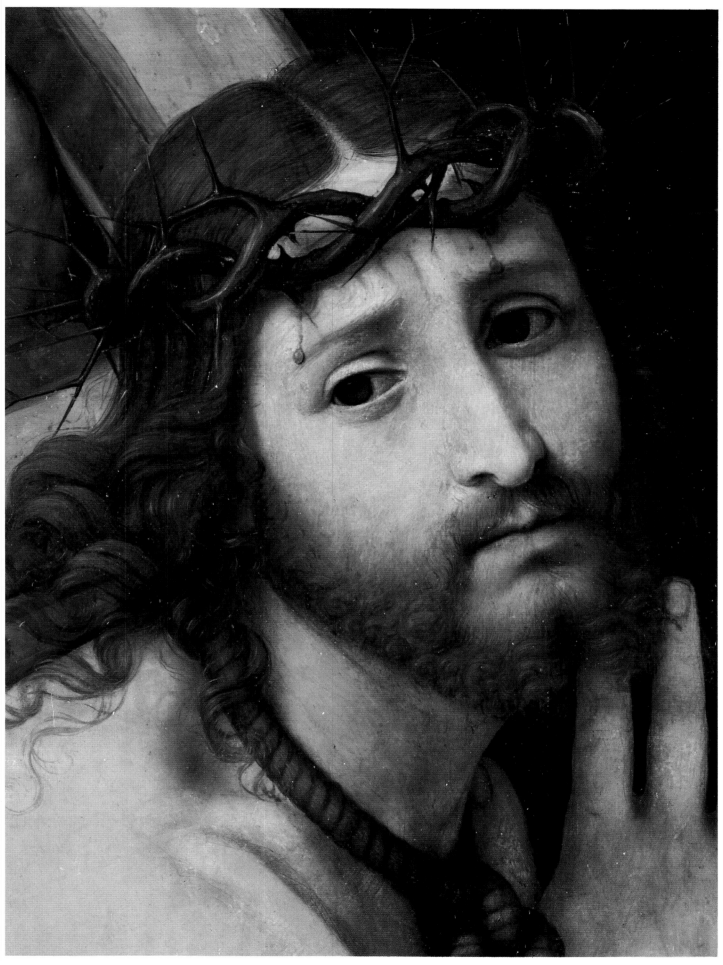

ANDREA SOLARIO, *CHRIST CARRYING THE CROSS*

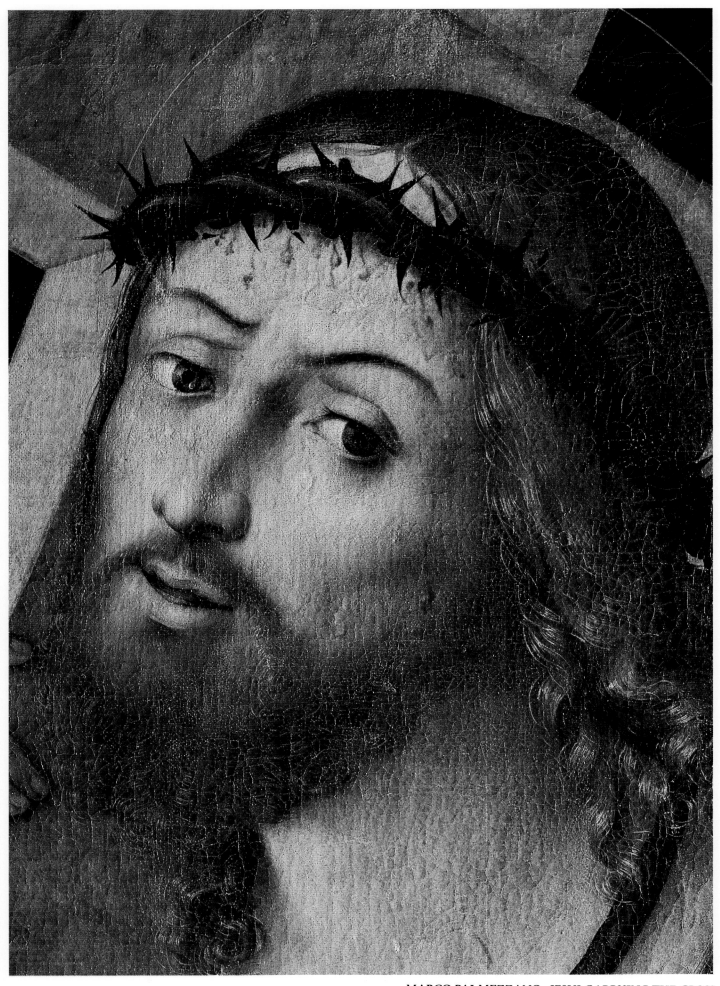

MARCO PALMEZZANO, *JESUS CARRYING THE CROSS*

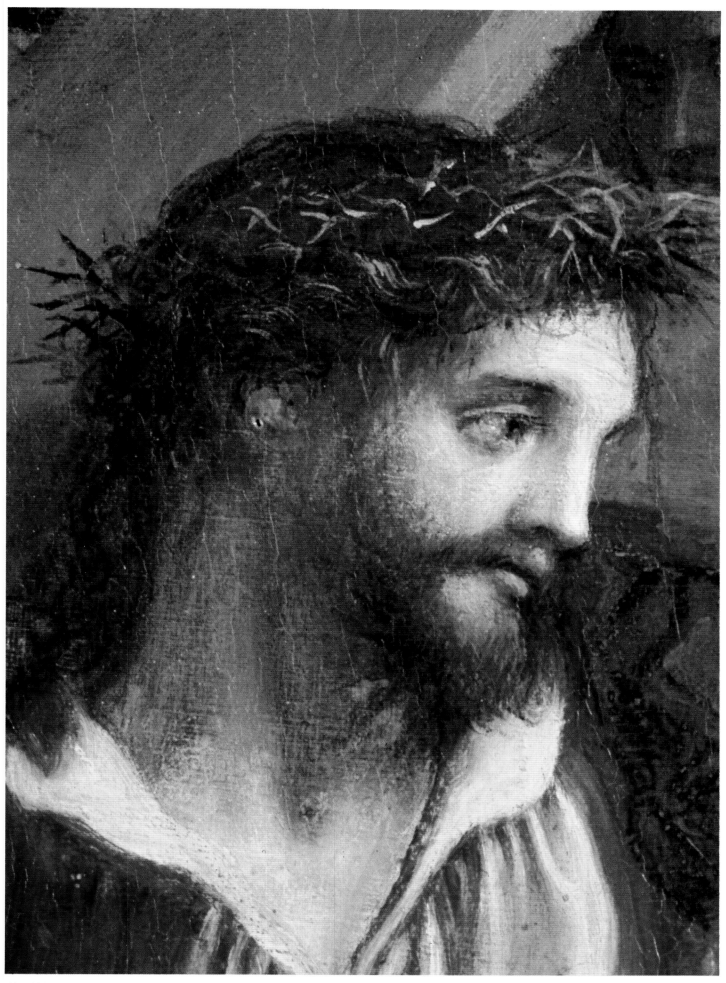

ALESSANDRO ALLORI, *SIMON OF CIRENE HELPING JESUS TO CARRY THE CROSS*

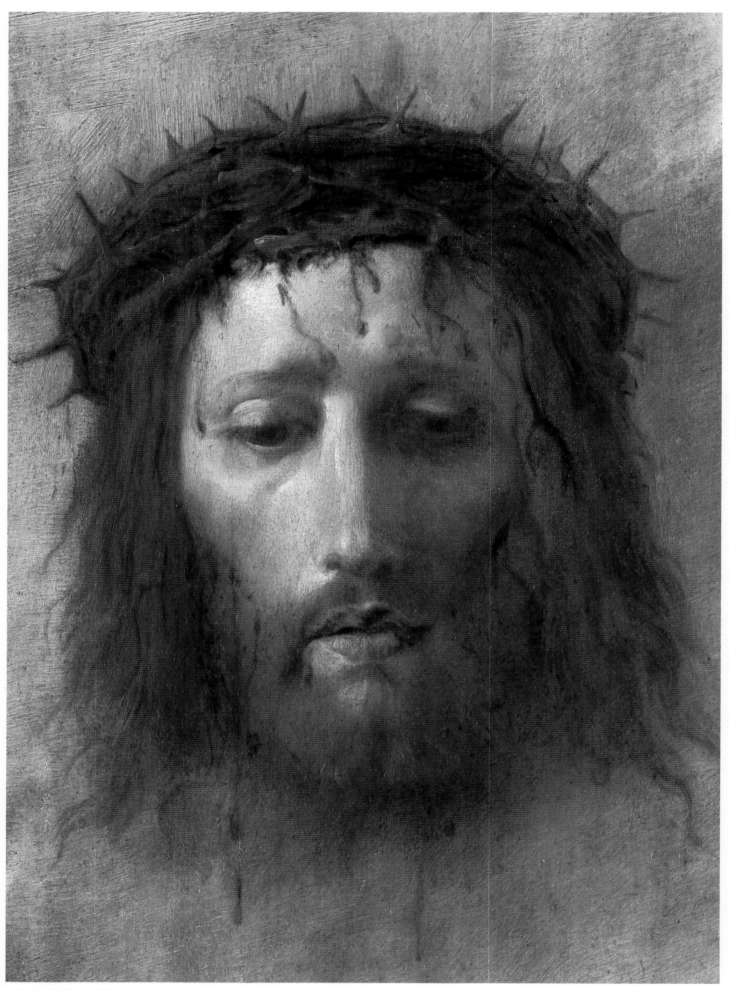

DOMENICO FETTI, *THE VEIL OF VERONICA*

GEORGES ROUAULT, *ECCE HOMO*

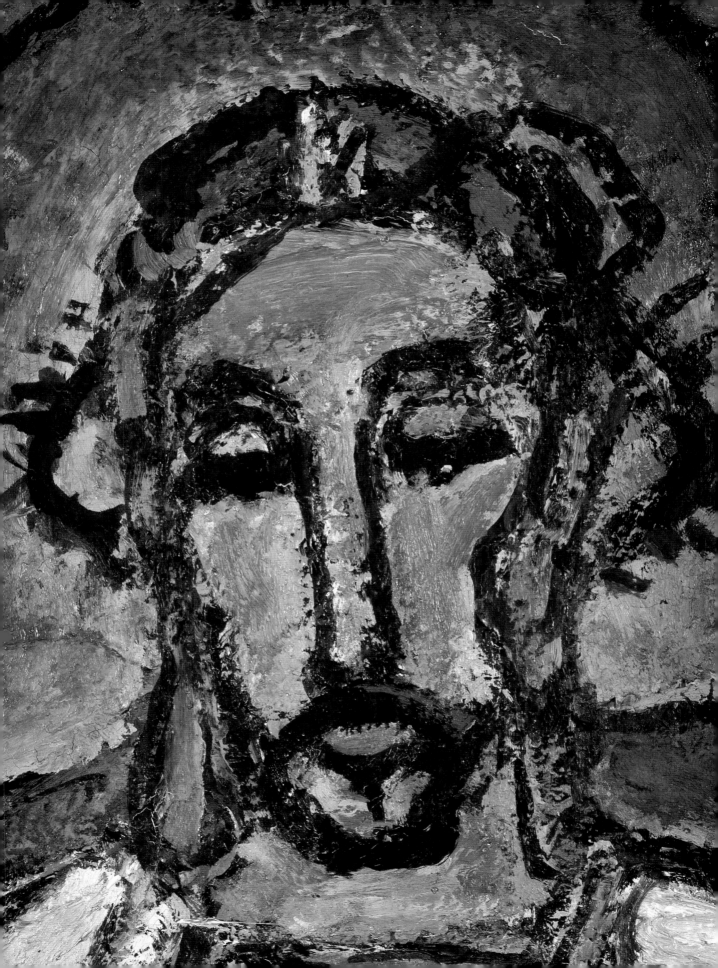

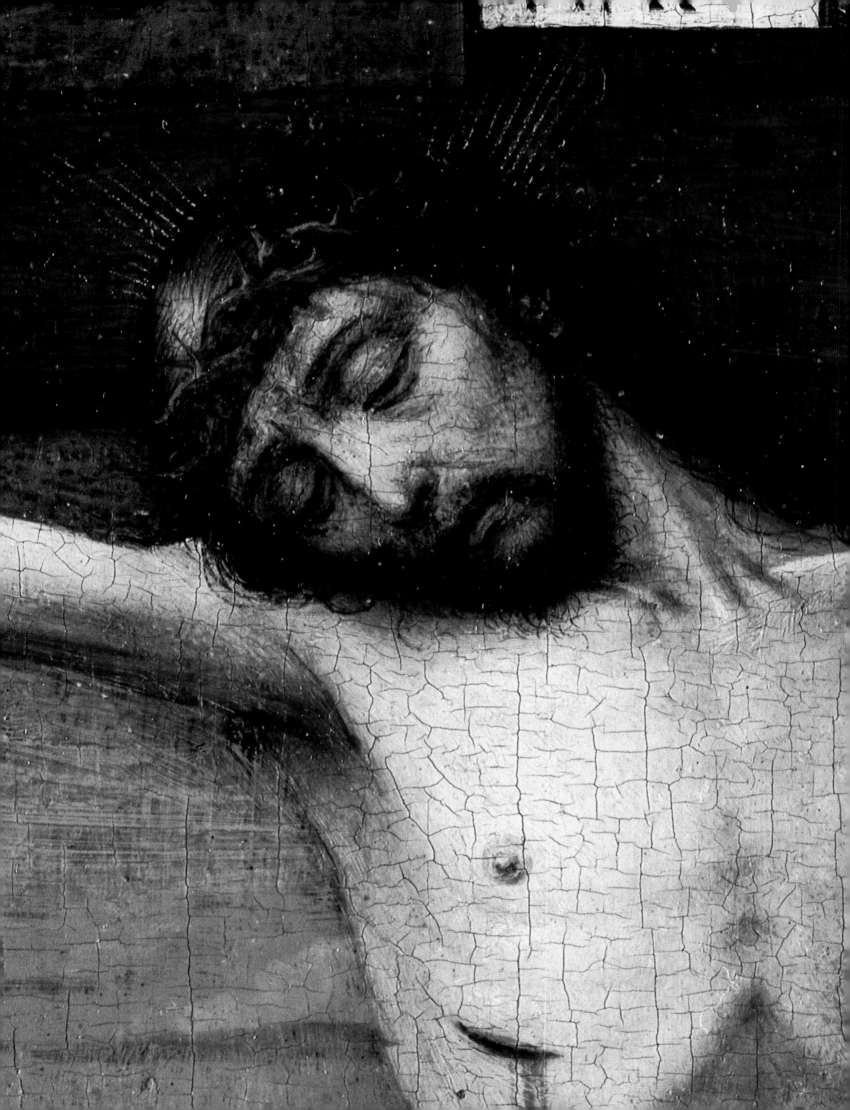

*A*nd they crucified him, and parted his garments, casting lots: that it might be fulfilled which was spoken by the prophet, They parted my garments among them, and upon my vesture did they cast lots. MATTHEW 27:35

Now from the sixth hour there was darkness over all the land unto the ninth hour. MATTHEW 27:45

And when Jesus had cried with a loud voice, he said, FATHER, INTO THY HANDS I COMMEND MY SPIRIT: and having said thus, he gave up the ghost. LUKE 23:46

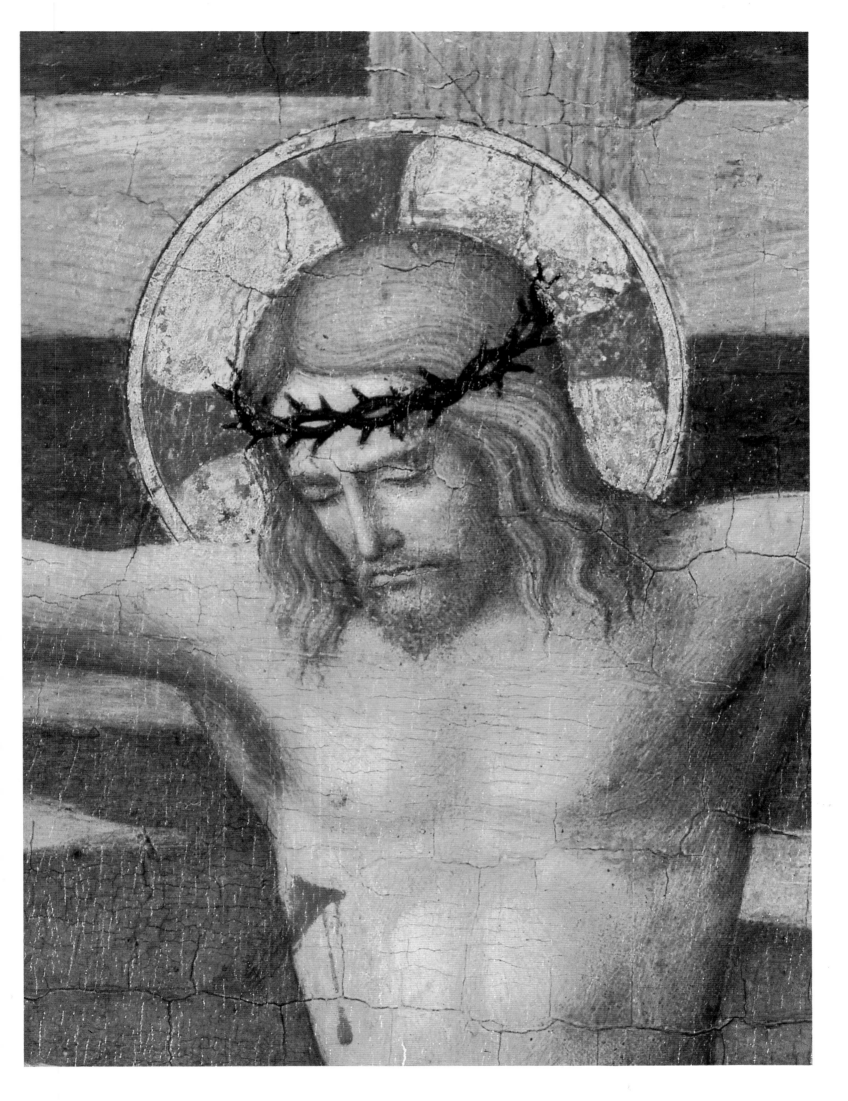

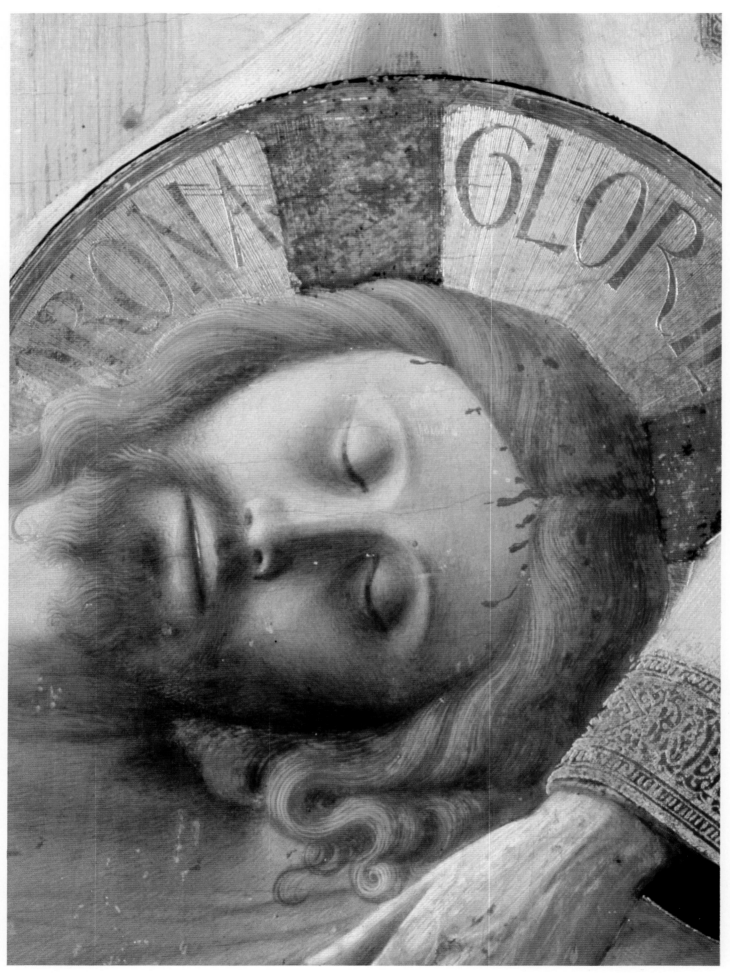

FRA ANGELICO, *DEPOSITION OF CHRIST*

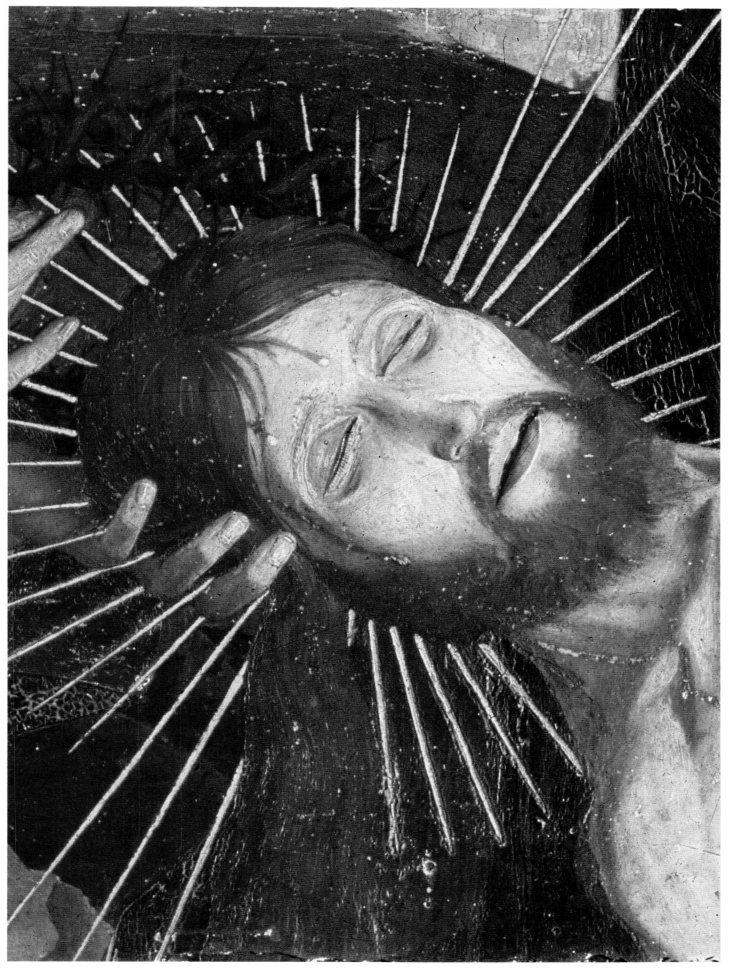

SCHOOL OF AVIGNON, *VILLENEUVE PIETA*

And, behold, the veil of the temple was rent in twain from the top
to the bottom; and the earth did quake, and the rocks rent. And the
graves were opened; and many bodies of the saints which slept arose,
and came out of the graves after his resurrection, and went into the
holy city, and appeared unto many. MATTHEW 27:51–53

CARLO CRIVELLI, *PIETA*

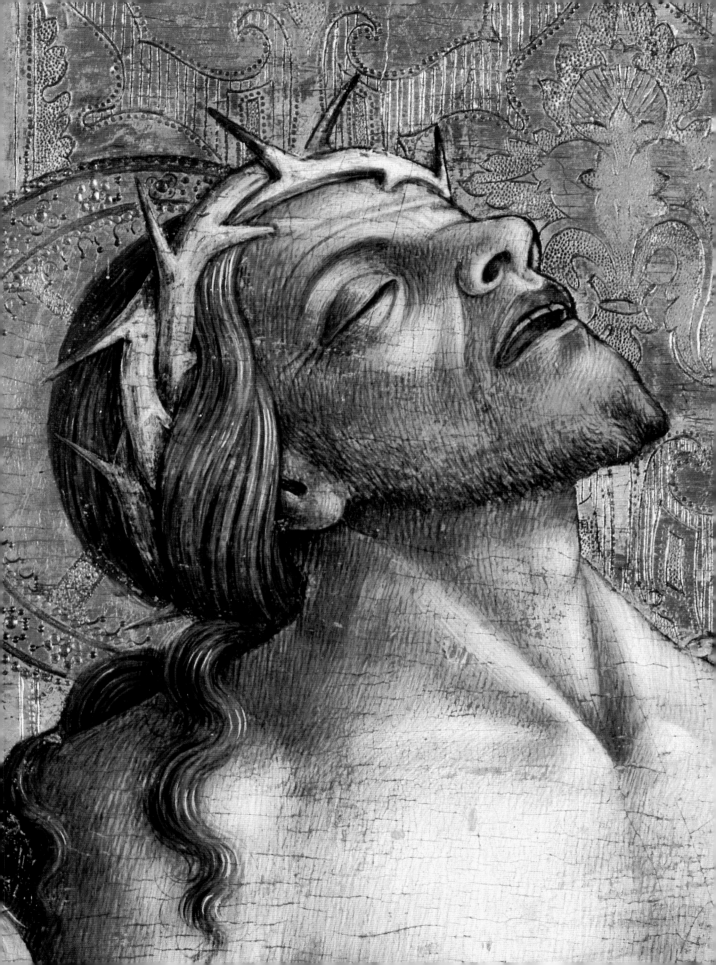

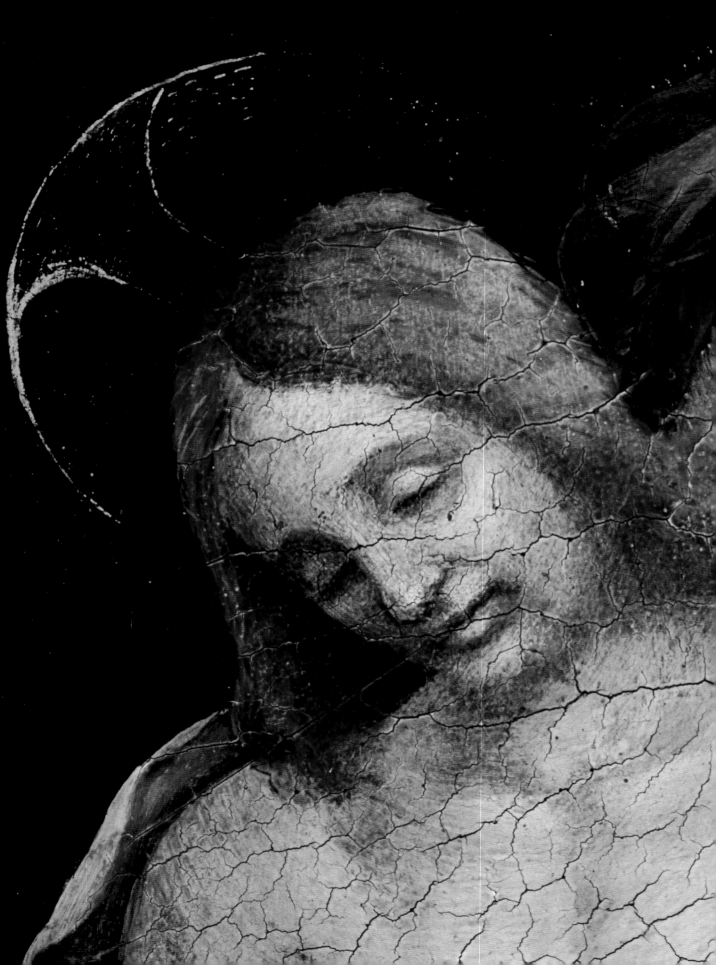

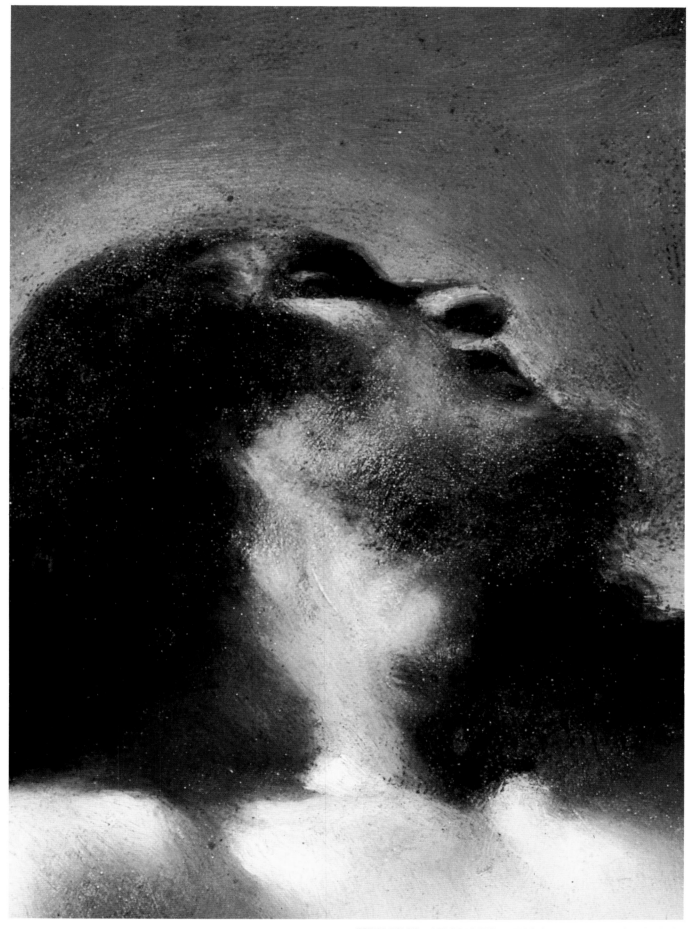

GUERCINO, *ANGELS WEEPING OVER THE DEAD CHRIST*

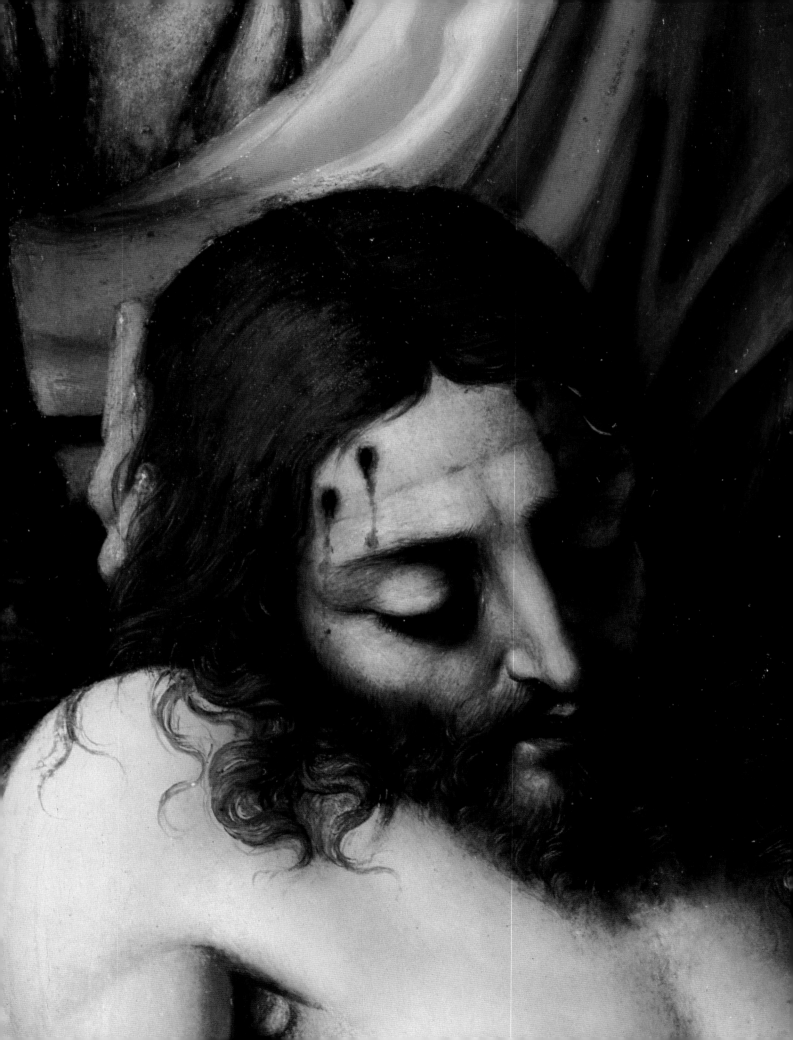

When the even was come, there came a rich man of Arimathaea, named Joseph, who also himself was Jesus disciple: He went to Pilate, and begged the body of Jesus. Then Pilate commanded the body to be delivered. And when Joseph had taken the body, he wrapped it in a clean linen cloth, and laid it in his own new tomb, which he had hewn out in the rock: and he rolled a great stone to the door of the sepulchre, and departed. MATTHEW 27:57–60

HIS TRIUMPH

In the end of the sabbath, as it began to dawn toward the first day of the week, came Mary Magdalene and the other Mary to see the sepulchre. And, behold, there was a great earthquake: for the angel of the Lord descended from heaven, and came and rolled back the stone from the door, and sat upon it. His countenance was like lightning, and his raiment white as snow: and for fear of him the keepers did shake, and became as dead men. And the angel answered and said unto the women, Fear not ye: for I know that ye seek Jesus, which was crucified. He is not here: for he is risen, as he said. MATTHEW 28:1–6

PIERO DELLA FRANCESCA, *THE RESURRECTION*

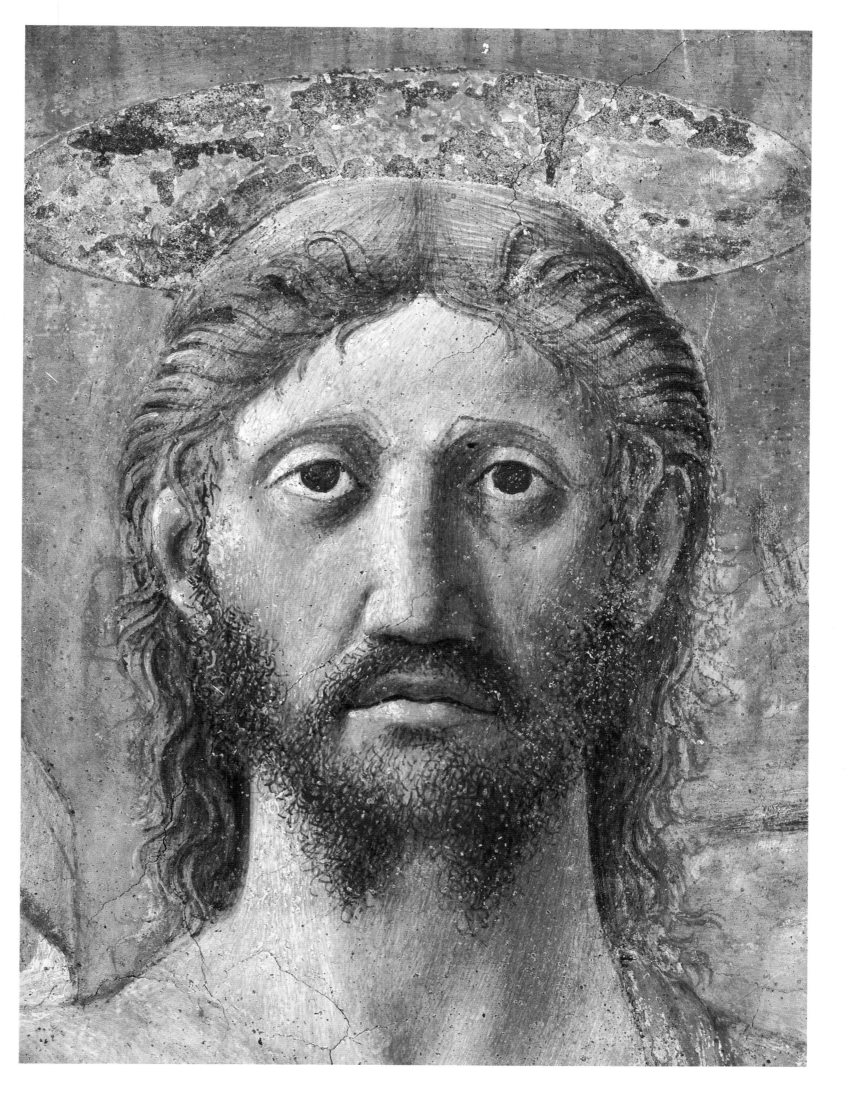

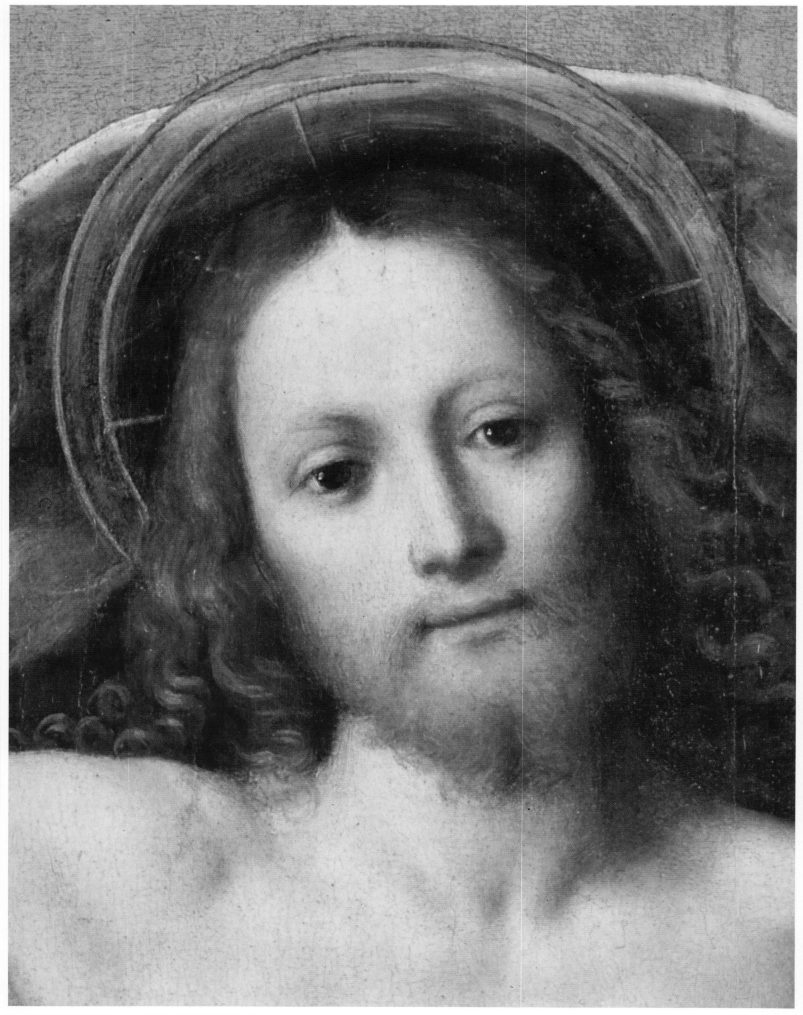

GAUDENZIO FERRARI, *THE RESURRECTION*

102

AMBROGIO BORGOGNONE, *THE RESURRECTION*

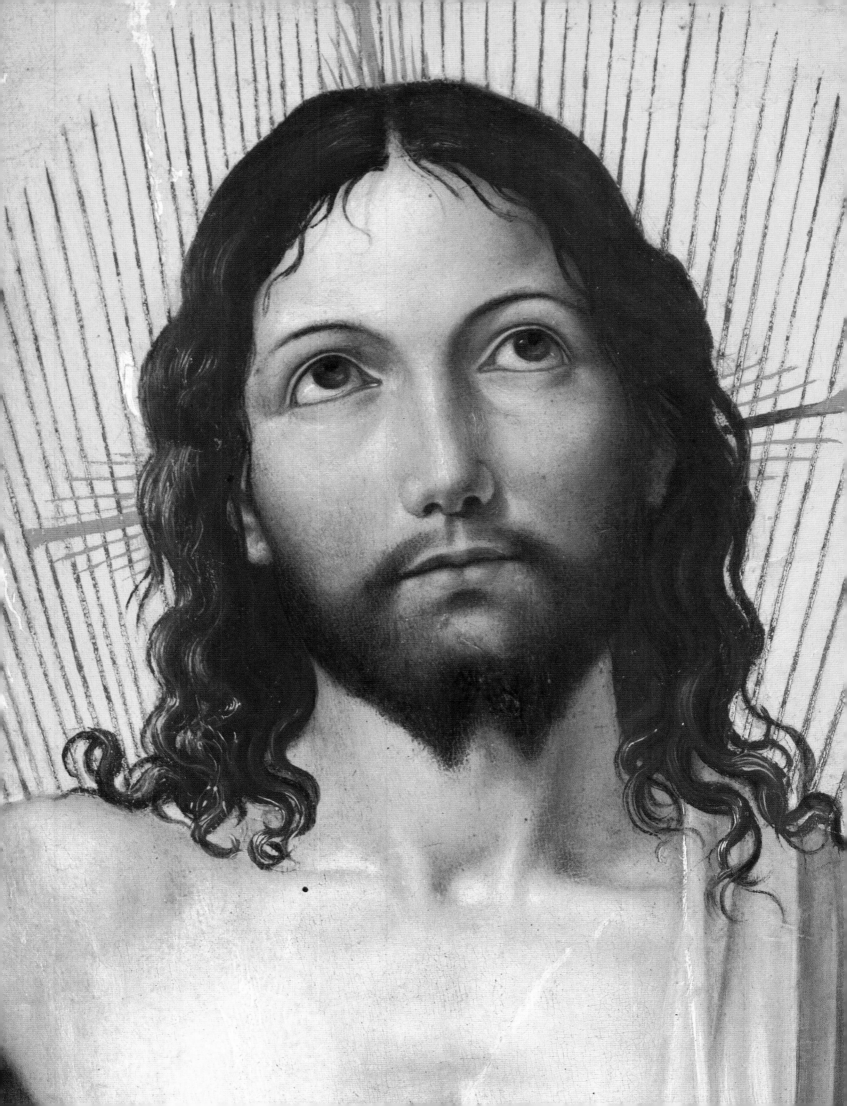

Now when Jesus was risen early the first day of the week, he appeared first to Mary Magdalene, out of whom he had cast seven devils. MARK 16:9

TOUCH ME NOT; FOR I AM NOT YET ASCENDED TO MY FATHER: BUT GO TO MY BRETHREN, AND SAY UNTO THEM, I ASCEND UNTO MY FATHER, AND YOUR FATHER; AND TO MY GOD, AND YOUR GOD. JOHN 20:17

ANDREA ORCAGNA, *NOLI ME TANGERE*

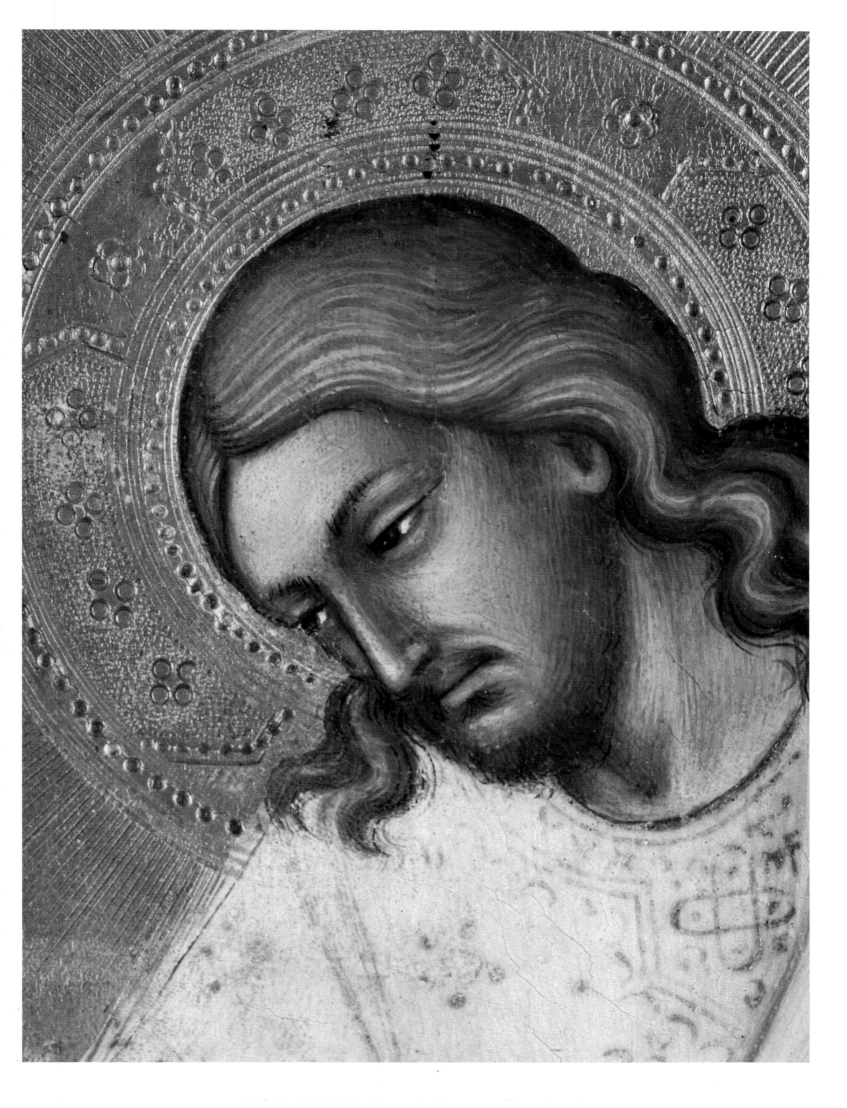

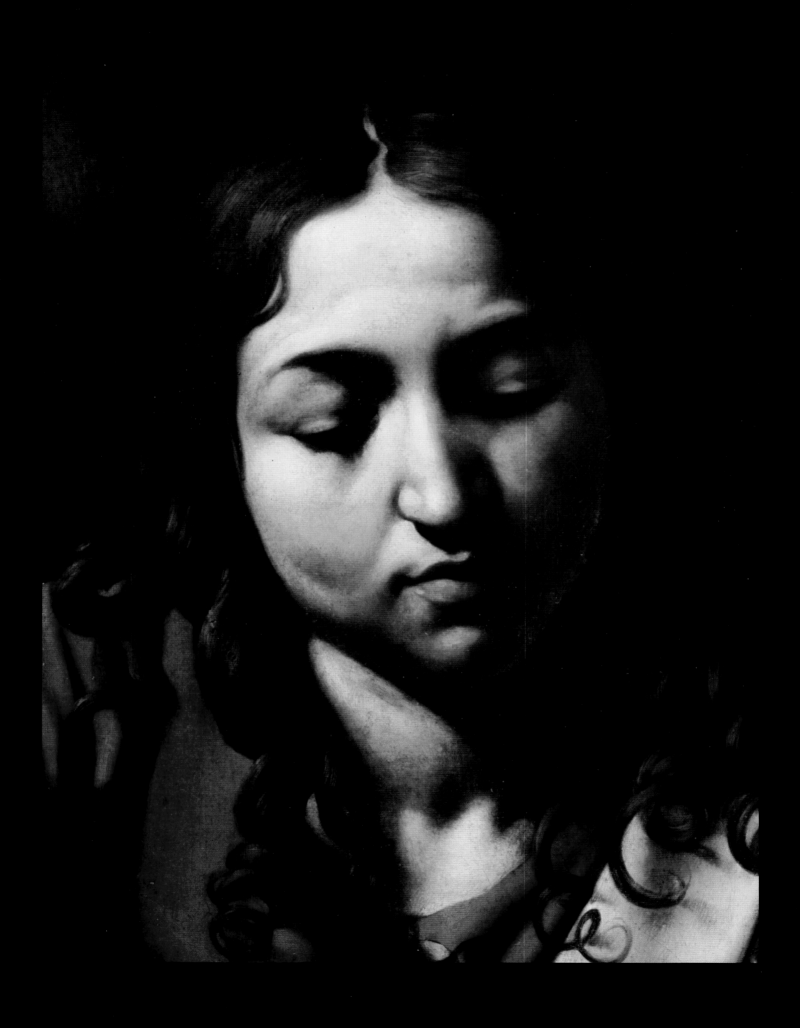

Then the same day at evening, being the first day of the week, when the doors were shut where the disciples were assembled for fear of the Jews, came Jesus and stood in the midst, and saith unto them, PEACE BE UNTO YOU. JOHN 20:19

MICHELANGELO CARAVAGGIO, *THE SUPPER AT EMMAUS*

*T*hen said Jesus to them again, *PEACE BE UNTO YOU: AS MY FATHER HATH SENT ME, EVEN SO SEND I YOU.* And when he had said this, he breathed on them, and saith unto them, *RECEIVE YE THE HOLY GHOST: WHOSE SOEVER SINS YE REMIT, THEY ARE REMITTED UNTO THEM; AND WHOSE SOEVER SINS YE RETAIN, THEY ARE RETAINED.* JOHN 20:20–23

DIEGO RODRIGUEZ VELAZQUEZ, *THE SUPPER AT EMMAUS*

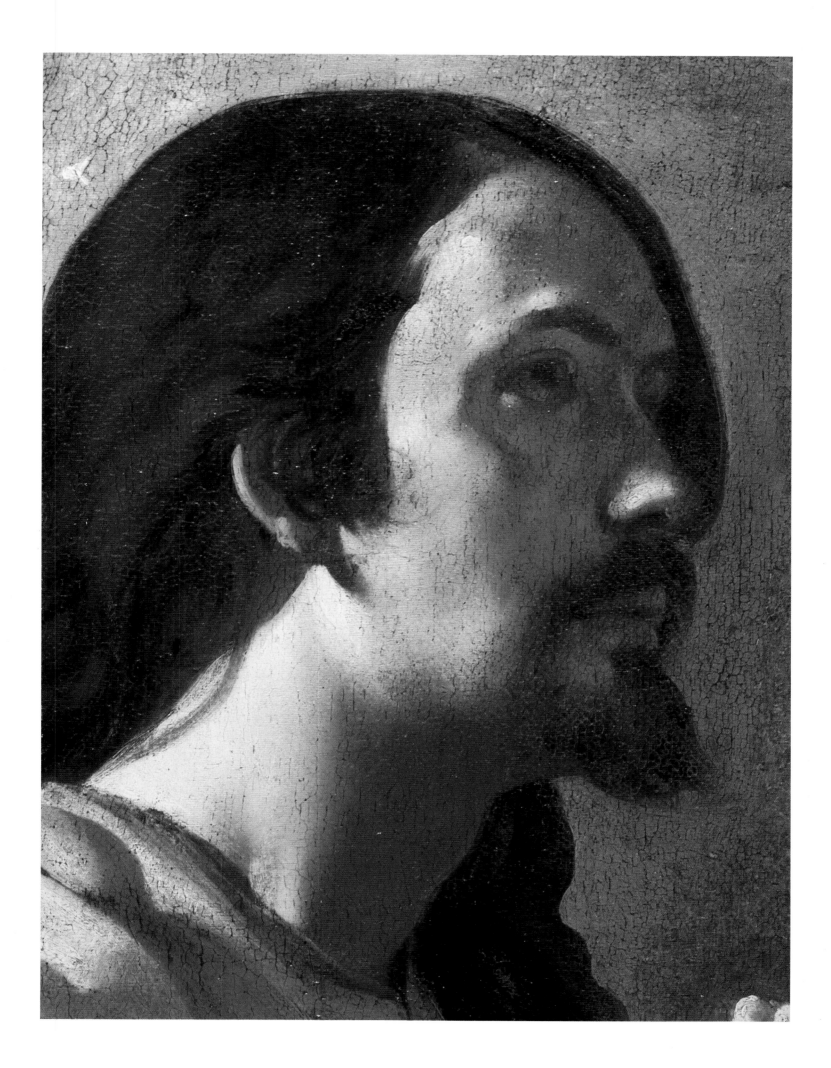

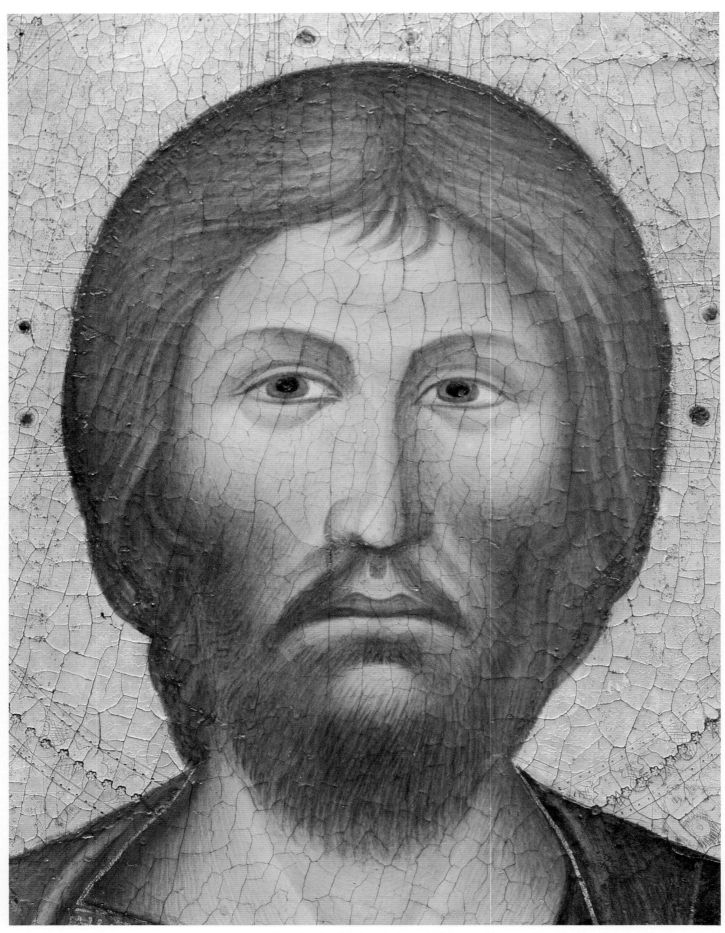

FOLLOWER OF CIMABUE, *CHRIST BETWEEN ST. PETER AND ST. JAMES MAJOR*

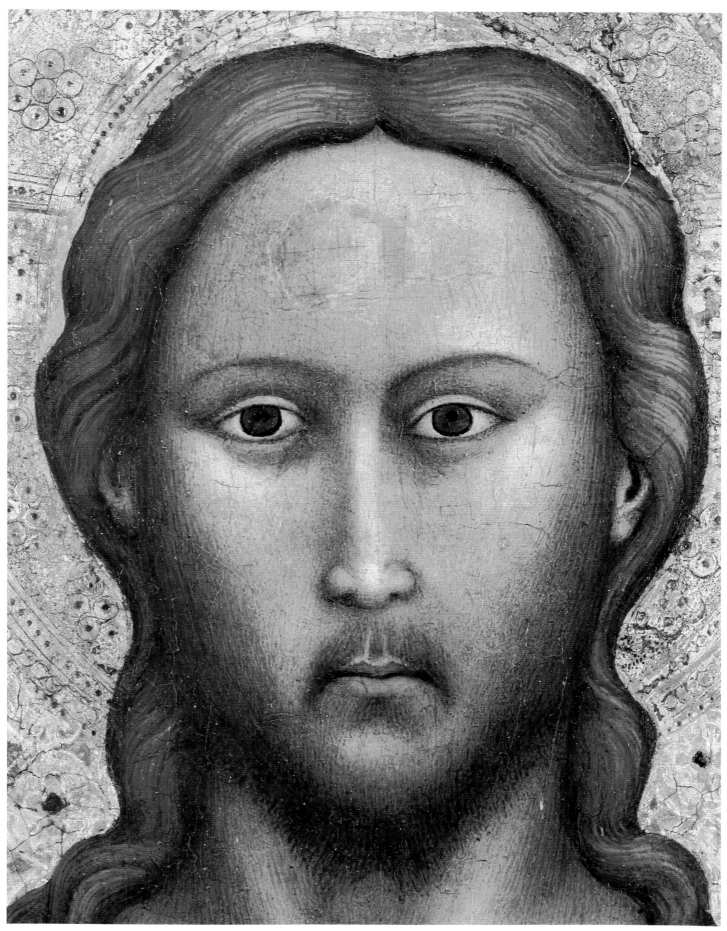

ATTRIBUTED TO TOMASSO DI NICCOLO, *HEAD OF CHRIST*

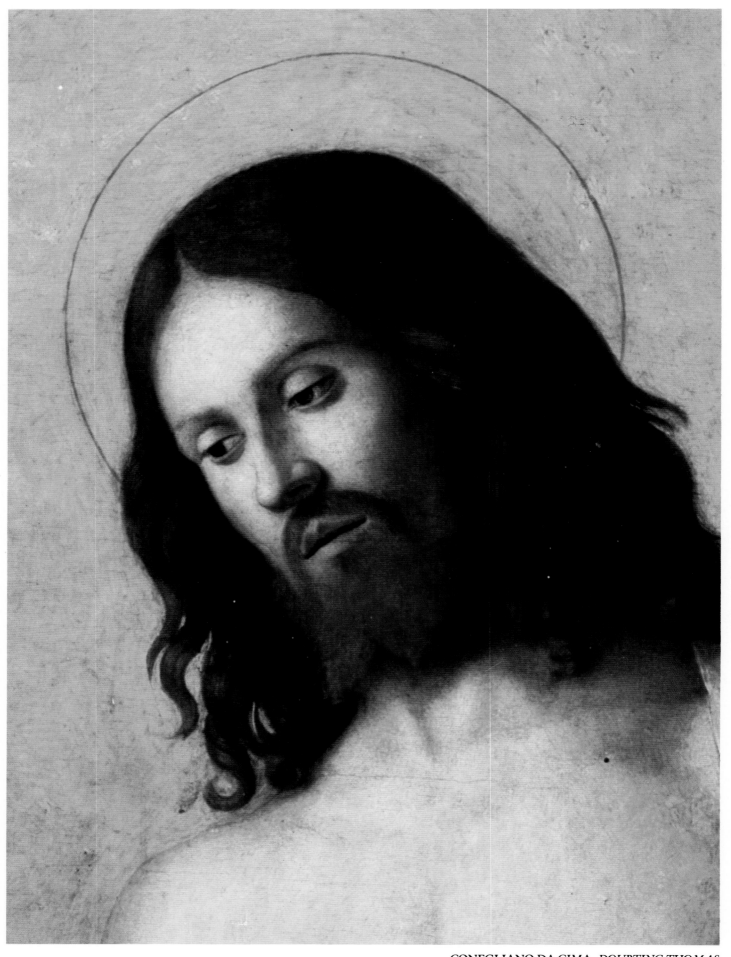

CONEGLIANO DA CIMA, *DOUBTING THOMAS*

THOMAS, BECAUSE THOU HAST SEEN ME, THOU HAST BELIEVED: BLESSED ARE THEY THAT HAVE NOT SEEN, AND YET HAVE BELIEVED. JOHN 20:29

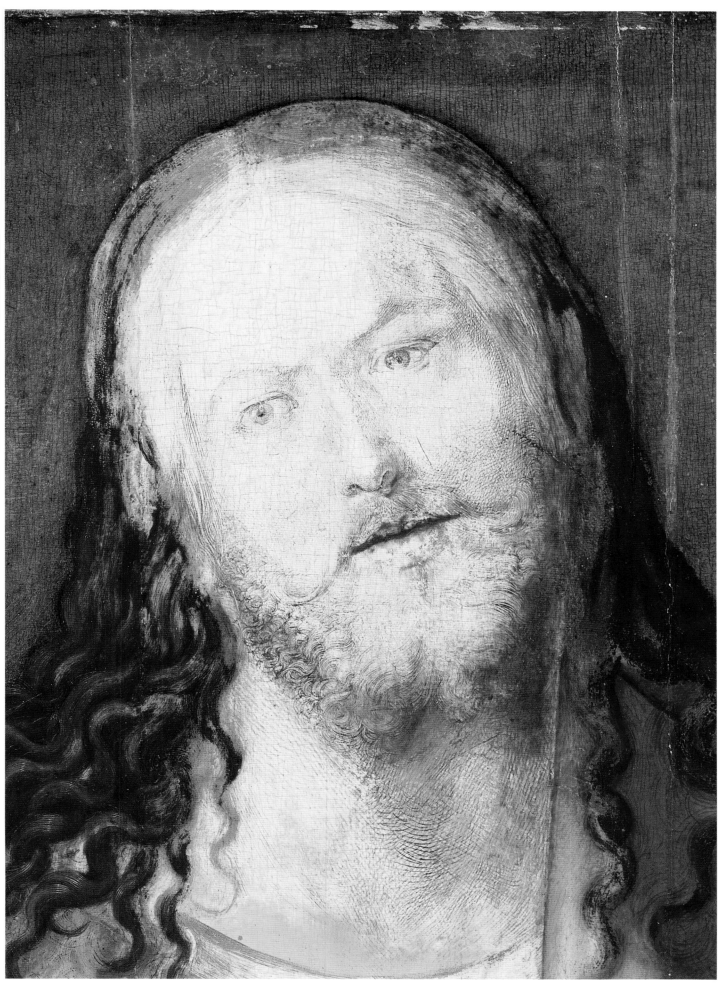

ALBRECHT DURER, *SALVATOR MUNDI*

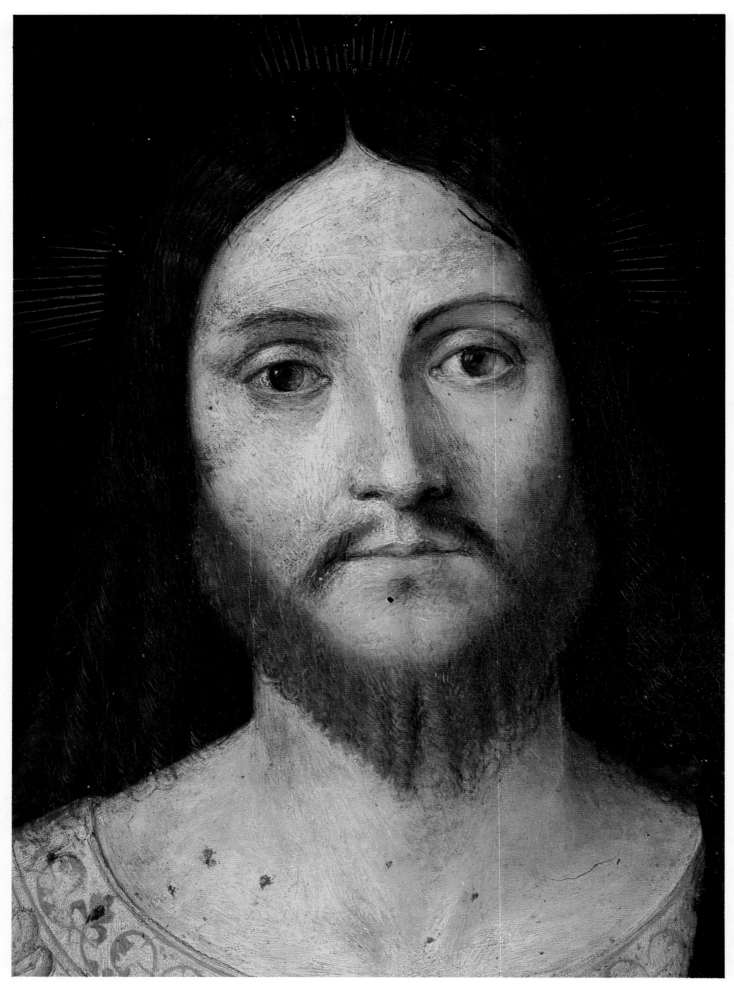

LOMBARD SCHOOL, *CHRIST BLESSING*

JAN VAN SCOREL, *BENEDICTION OF CHRIST*

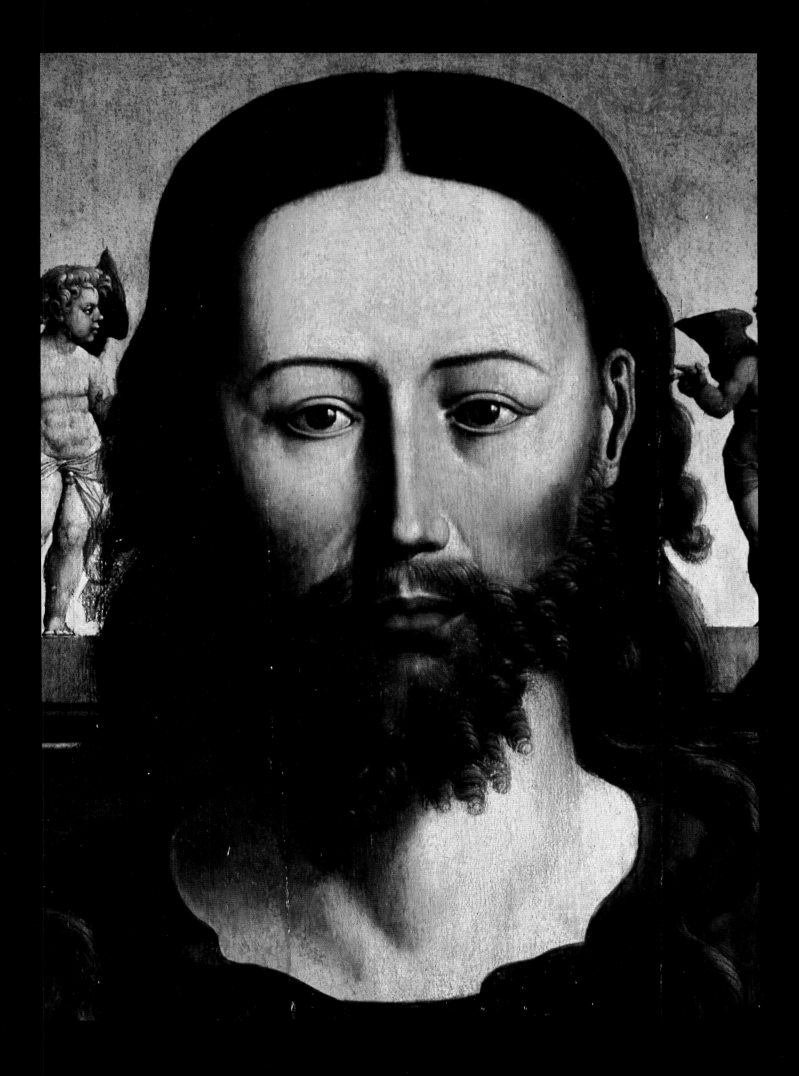

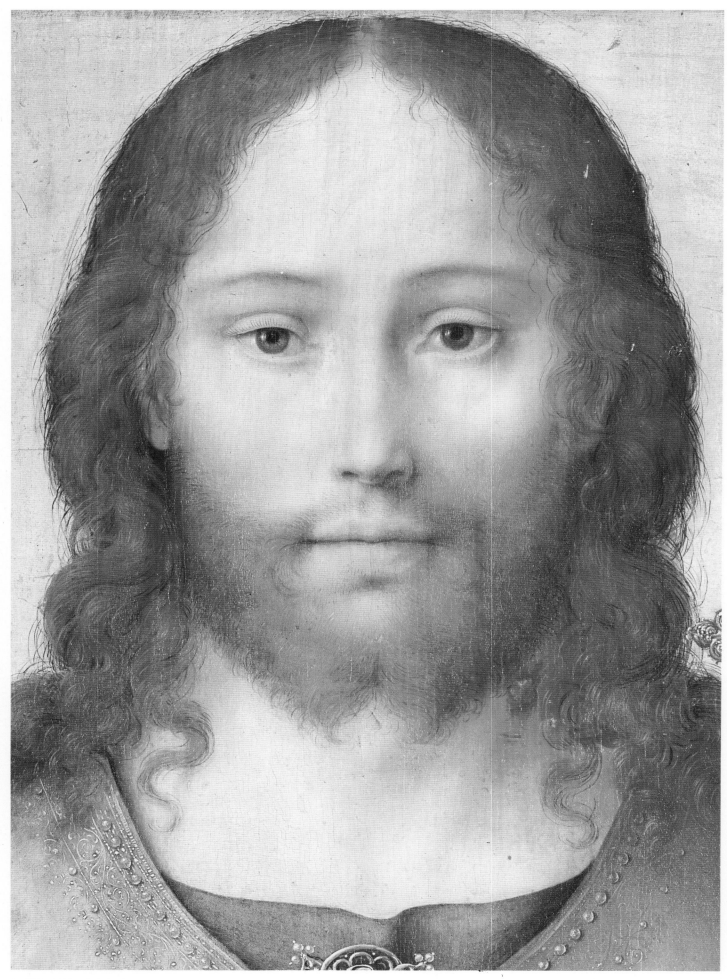

CLEVE VAN JOOS, *CHRIST BLESSING*

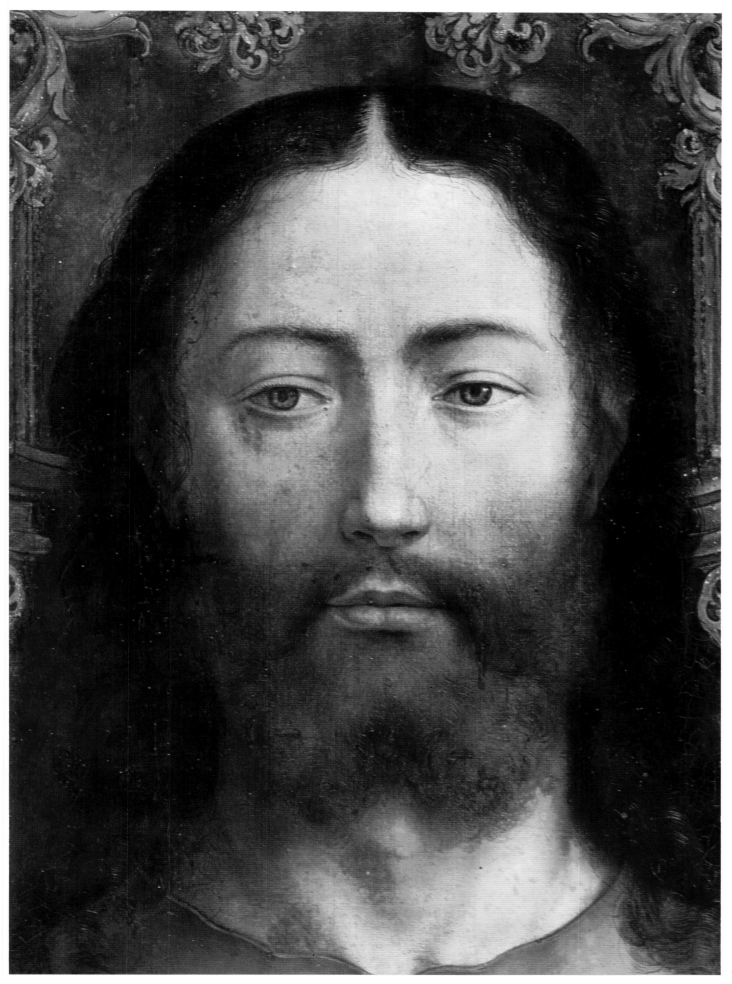

MABUSE, *CHRIST BETWEEN THE VIRGIN AND ST. JOHN THE BAPTIST*

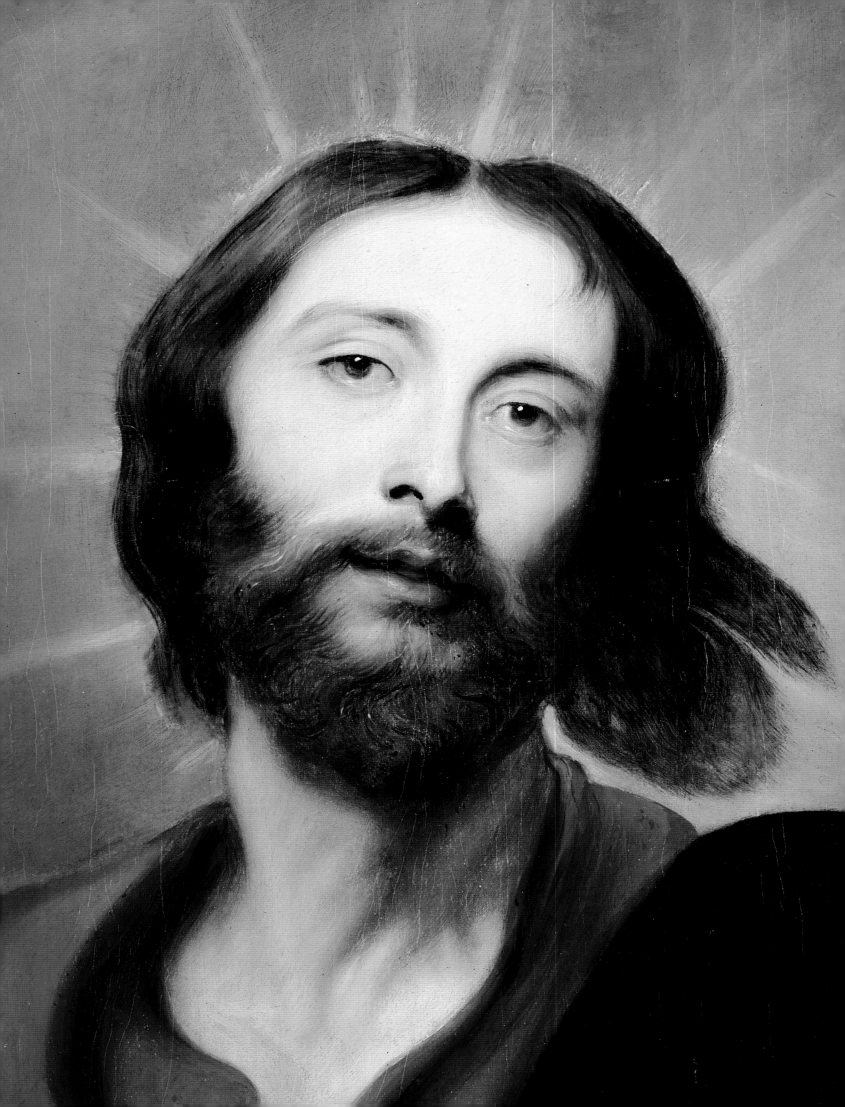

*A*LL POWER IS GIVEN UNTO ME IN HEAVEN
AND IN EARTH. GO YE THEREFORE, AND
TEACH ALL NATIONS, BAPTIZING THEM IN THE
NAME OF THE FATHER, AND OF THE SON, AND
OF THE HOLY GHOST: TEACHING THEM TO
OBSERVE ALL THINGS WHATSOEVER I HAVE
COMMANDED YOU: AND, LO, I AM WITH YOU
ALWAYS, EVEN UNTO THE END OF THE
WORLD. MATTHEW 28:18–20

*A*nd he led them out as far as to Bethany, and he lifted up his hands,
and blessed them. And it came to pass, while he blessed them,
he was parted from them, and carried up into heaven. LUKE 24:50–51

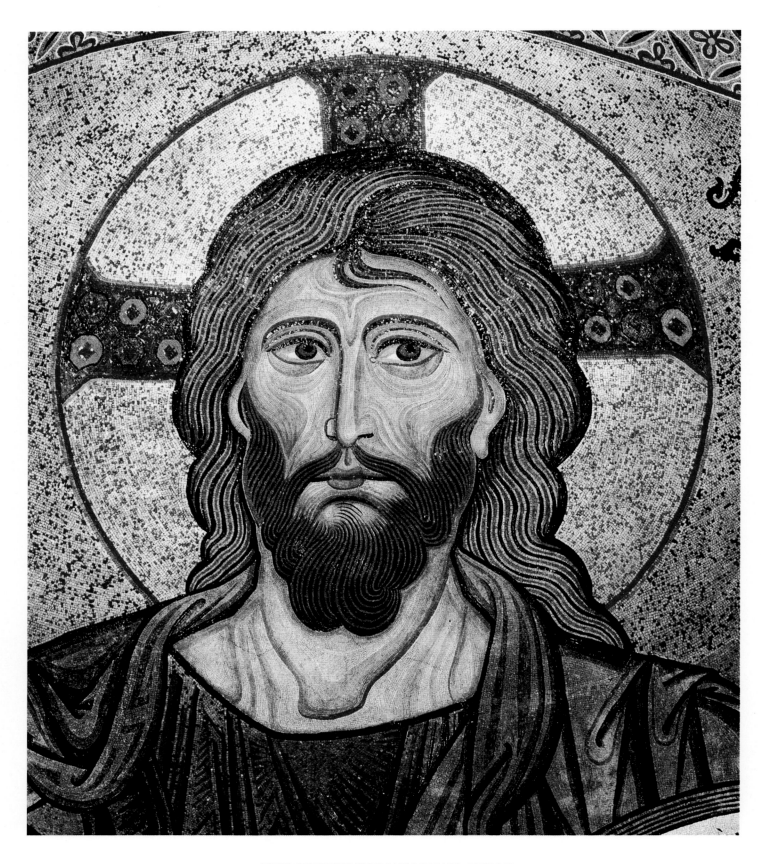

12TH CENTURY SICILIAN MOSAIC, *DUOMO*

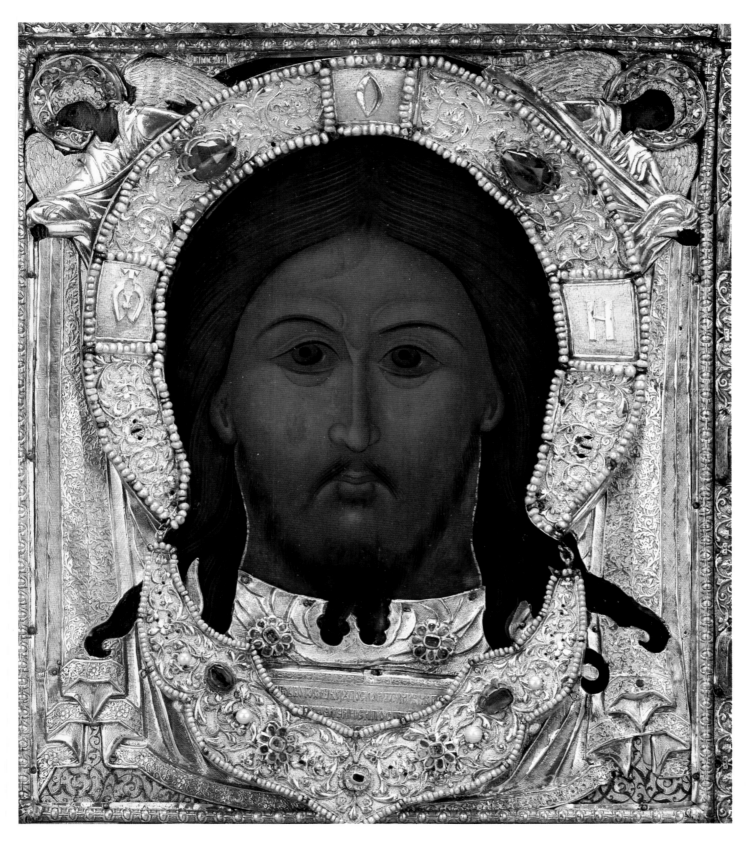

ARTIST OF THE KREMLIN, *ICON WITH THE TRUE IMAGE OF CHRIST*

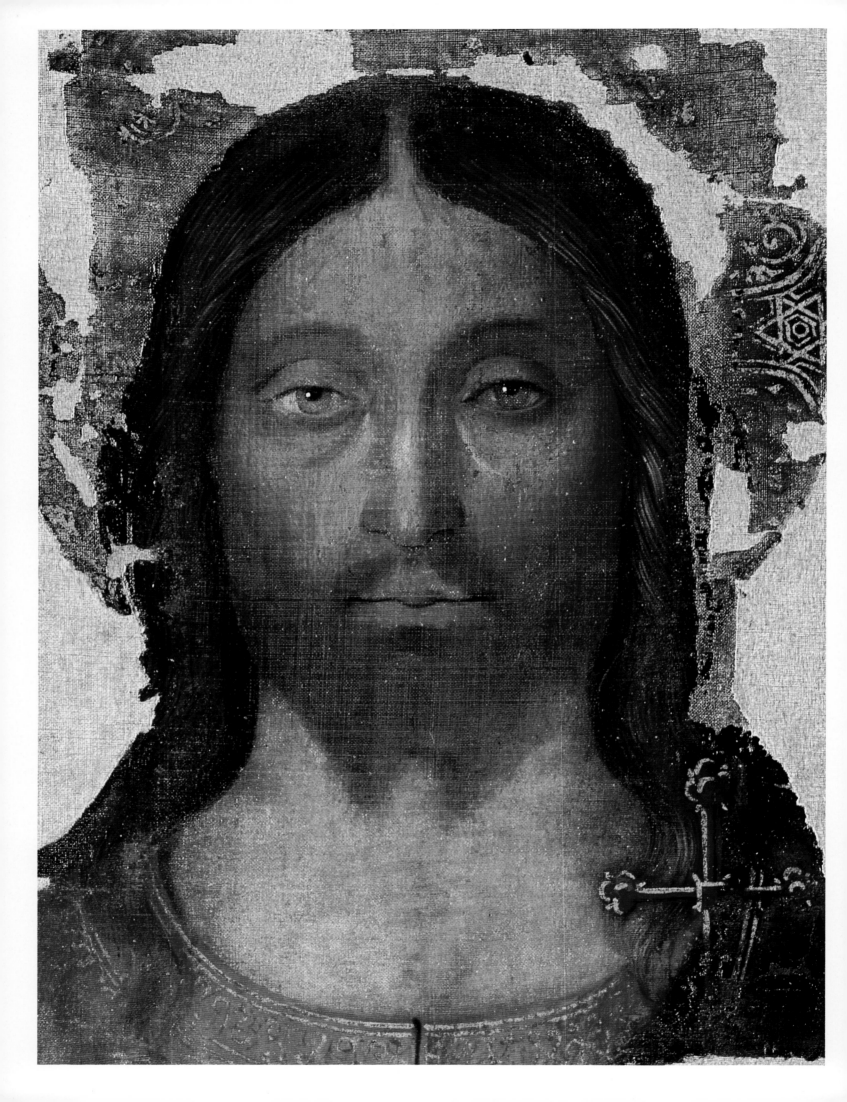

AND THERE SHALL BE SIGNS IN THE SUN, AND IN THE MOON, AND IN THE STARS; AND UPON THE EARTH DISTRESS OF NATIONS, WITH PERPLEXITY; THE SEA AND THE WAVES ROARING; MEN'S HEARTS FAILING THEM FOR FEAR, AND FOR LOOKING AFTER THOSE THINGS WHICH ARE COMING ON THE EARTH: FOR THE POWERS OF HEAVEN SHALL BE SHAKEN. AND THEN SHALL THEY SEE THE SON OF MAN COMING IN A CLOUD WITH POWER AND GREAT GLORY. AND WHEN THESE THINGS BEGIN TO COME TO PASS, THEN LOOK UP, AND LIFT UP YOUR HEADS; FOR YOUR REDEMPTION DRAWETH NIGH. LUKE 21:25–28

Behold, he cometh with clouds; and every eye shall see him, and they also which pierced him: and all kindreds of the earth shall wail because of him. Even so, Amen. I AM ALPHA AND OMEGA, THE BEGINNING AND THE ENDING, saith the Lord, WHICH IS, AND WHICH WAS, AND WHICH IS TO COME, THE ALMIGHTY. REVELATION 1:7–8

GRUNEWALD, *CHRIST RISING*

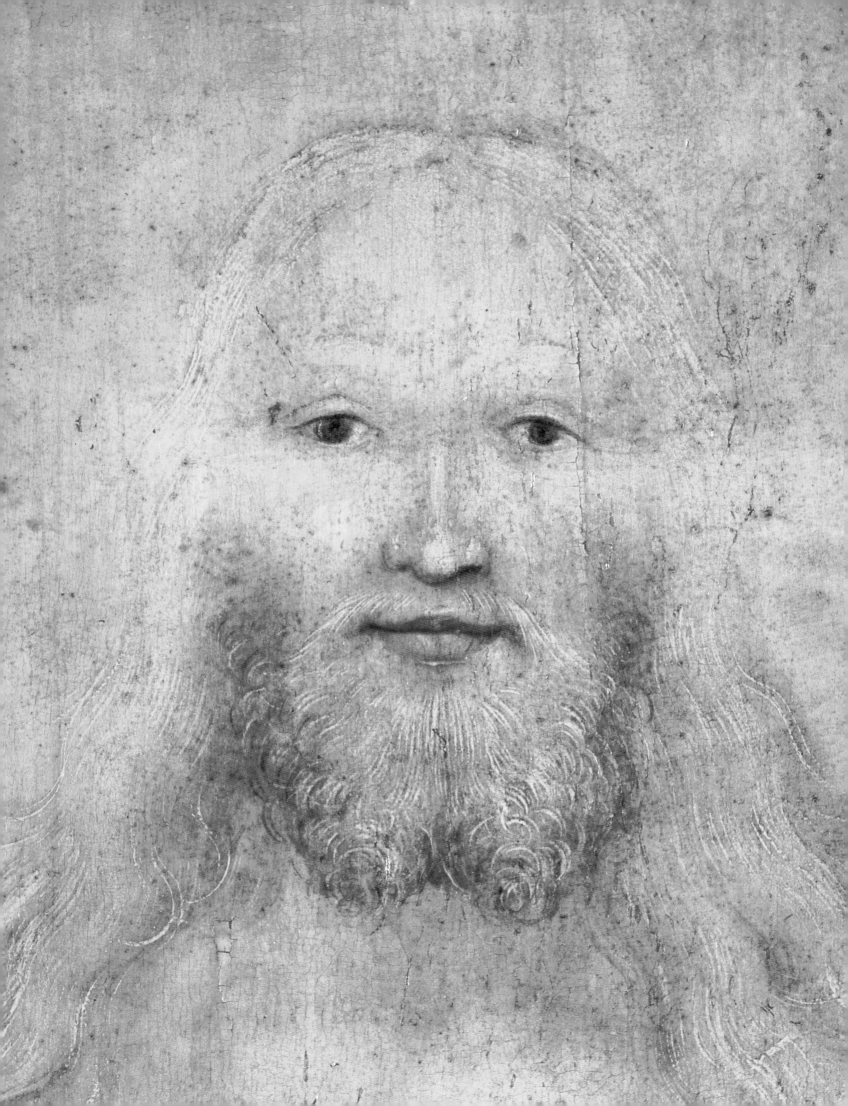

LIST OF COLOR PLATES

Note: All the reproductions in this book are details.

52.
DAVID, Gerard, Flemish, active about
 1484-died 1523
Christ Taking Leave of His Mother
Courtesy of The Metropolitan Museum of Art,
 New York
Bequest of Benjamin Altman, 1913

53.
RAPHAEL, Italian (Umbrian), 1483-1520
The Transfiguration
The Vatican Museum, Rome
Courtesy of Stockphotos, Inc., New York

55.
MAES, Nicolaes, Dutch, 1634-93
Christ Blessing the Children
Courtesy of the Trustees,
 The National Gallery, London

56.
PACECCO de Rosa, Italian (Neapolitan),
 c. 1600-1654
Christ Blessing the Children
Courtesy of Stockphotos, Inc., New York

57.
RIBERA, José de, Spanish, 1591(?)-1562
The Savior
The Prado, Madrid
Courtesy of Stockphotos, Inc., New York

59.
EL GRECO (Domenikos Theotocopoulos), Spanish,
 1541/48-1614
Christ Driving the Money Changers from the Temple
Courtesy of The Minneapolis Institute of Arts

60.
RUBENS, Peter Paul (Flemish), 1577-1640
Christ and Mary Magdalen
Alte Pinakothek, Munich
Courtesy of Scala/Art Resource, New York

61.
TINTORETTO, Jacopo Robusti, Italian (Venetian),
 1518-94
Christ at the Home of Mary and Martha
Alte Pinakothek, Munich
Courtesy of Stockphotos, Inc., New York

62.
LOTTO, Lorenzo, Italian (Venetian), c. 1480-1556
Christ and the Woman Taken in Adultery
The Louvre, Paris
Courtesy of Giraudon/Art Resource, New York

63.
CRANACH, Lucas, the Elder, German, 1472-1553
Christ and the Adulteress
Courtesy of The Metropolitan Museum of Art,
 New York
The Jack and Belle Linsky Collection, 1982

64.
TITIAN (Tiziano Vecelli), Italian (Venetian),
 1487/90-1576
The Tribute Money
Courtesy of the Trustees,
 The National Gallery, London

65.
MASACCIO, Italian (Florentine), 1401-28
The Tribute Money
Brancacci Chapel, Church of Santa Maria
 del Carmine, Florence
Courtesy of Scala/Art Resource, New York

66.
REMBRANDT van Ryn (attributed to), Dutch,
 1606-1669
Head of Christ
Courtesy of The Metropolitan Museum of Art,
 New York
Dr. and Mrs. Isaac D. Fletcher Collection

SUFFERING

69.
DALI, Salvador, Spanish, 1904-
The Sacrament of the Last Supper
Courtesy of the National Gallery of Art, Washington
Chester Dale Collection

70.
BENVENUTO di Giovanni, Italian (Sienese),
 c. 1436-1518
Passion of Our Lord: The Agony in the Garden
Courtesy of the National Gallery of Art, Washington
Samuel H. Kress Collection

71.
BOSCH, Hieronymus (attributed to), Dutch,
 c. 1450-1516
Christ Before Pilate
Courtesy of The Art Museum, Princeton University
Gift of Allan Marquand

72.
BACCHIACCA, (Francesco Ubertini Verdi), Italian
 (Florentine), 1494-1557
The Flagellation of Christ
Courtesy of the National Gallery of Art, Washington
Samuel H. Kress Collection

73.
VELAZQUEZ, Diego Rodriguez de Silva y, Spanish,
 1599-1660
*Christ After the Flagellation Contemplated by the
 Christian Soul*
Courtesy of the Trustees,
 The National Gallery, London

74.
MORALES, Luis de (El Divino), Spanish,
1509(?)-1581
Man of Sorrows
Courtesy of The Minneapolis Institute of Arts

75.
VERONESE, Paolo, Italian (Venetian), c. 1528-88
Christ Carrying the Cross
The Louvre, Paris
Courtesy of Giraudon/Art Resource, New York

76.
CARAVAGGIO, Michelangelo Merisi da, Italian,
 1571-1610
Ecce Homo
Palazzo Rosso, Genoa
Courtesy of Scala/Art Resource, New York

77.
TINTORETTO, Jacopo Robusti, Italian (Venetian),
 1518-94
Ecce Homo
Scuola di San Rocco, Venice
Courtesy of Scala/Art Resource, New York

79.
VAN DYCK, Anthony, Flemish, 1599-1641
The Mocking of Christ
Courtesy of The Art Museum, Princeton University
Gift of the Charles Ulrick and Josephine Bay
 Foundation, Inc., through
 Colonel C. Michael Paul

80.
GIORGIONE (attributed to), Italian, 1477/8-1510,
 or School of Giovanni Bellini, Italian,
 c. 1430/8-1516
Christ Bearing the Cross
Courtesy of Isabella Stewart Gardner Museum,
 Boston/Art Resource, New York

82.
MAINERI, Gian-Francesco da, Italian (Lombard),
 d. 1504/5
Christ Carrying the Cross
Galleria Doria-Pamphili, Rome
Courtesy of Stockphotos, Inc., New York

83.
SOLARIO, Andrea, Italian, (Milanese), 1495-1524
Christ Carrying the Cross
Courtesy of Stockphotos, Inc., New York

84.
PALMEZZANO, Marco, Italian, c. 1458/63-1539
Jesus Carrying the Crosss
Galleria Spada, Rome
Courtesy of Stockphotos, Inc., New York

85.
ALLORI, Alessandro, Italian (Florentine),
 1535-1607
Simon of Cirene Helping Jesus to Carry the Cross
Galleria Doria-Pamphili, Rome
Courtesy of Stockphotos, Inc., New York

86.
FETTI, Domenico, Italian (Roman), c. 1589-1623
The Veil of Veronica
Courtesy of the National Gallery of Art, Washington
Samuel H. Kress Collection

87.
ROUAULT, Georges, French, 1871-1958
Ecce Homo
Modern Religious Art Collection, The Vatican,
 Rome
Courtesy of Scala/Art Resource, New York

88.
DAVID, Gerard, Flemish, active about 1484-died
 1523
The Crucifixion
Courtesy of The Metropolitan Museum of Art,
 New York
Rogers Fund, 1909

91.
PESELLINO (Francesco di Stefano), Italian
 (Florentine), 1422-1457)
The Crucifixion with St. Jerome and St. Francis
Courtesy of the National Gallery of Art, Washington
Samuel H. Kress Collection

92.
ANGELICO, Fra, Italian (Florentine),
 c. 1387/1400-1455
Deposition of Christ
Museo di San Marco, Florence
Courtesy of Scala/Art Resource, New York

93.
SCHOOL OF AVIGNON (attributed to
 Charanton), French, 15th century
Villeneuve Pietà
The Louvre, Paris
Courtesy of Scala/Art Resource, New York

95.
CRIVELLI, Carlo, Italian (Venetian), c. 1430-1495
Pietà
Courtesy of The Philadelphia Museum of Art
John G. Johnson Collection

96.
LIPPI, Filippino, Italian (Florentine), c. 1457-1504
Pietà
Courtesy of the National Gallery of Art, Washington
Samuel H. Kress Collection

97.
GUERCINO, Italian (Bolognese), 1591-1666
Angels Weeping over the Dead Christ
Courtesy of the Trustees,
 The National Gallery, London

98.
SOLARIO, Andrea, Italian (Milanese), 1495-1524
Lamentation
Courtesy of the National Gallery of Art, Washington
Samuel H. Kress Collection